Coffee, Tea, and Chocolate

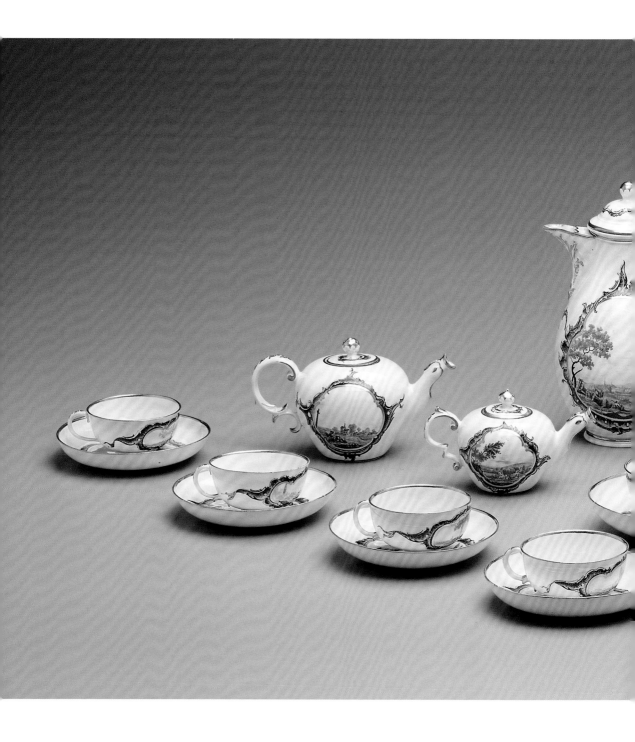

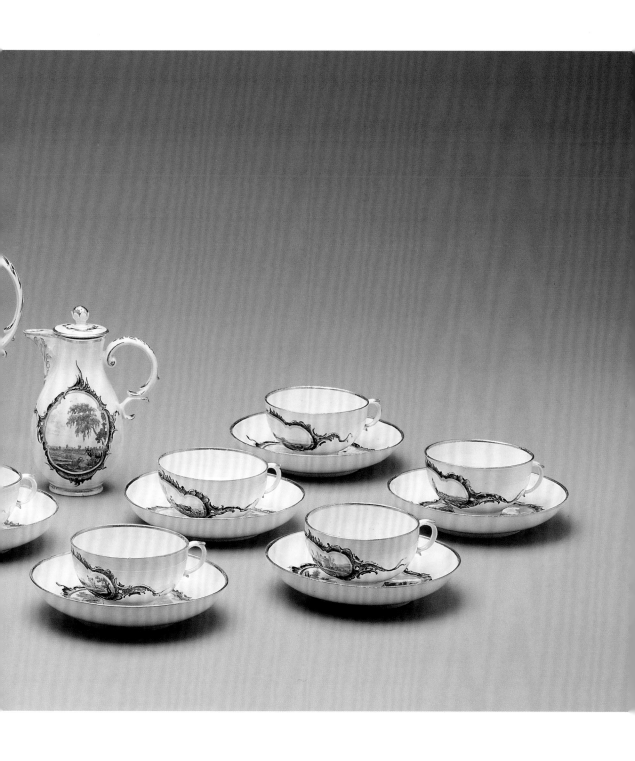

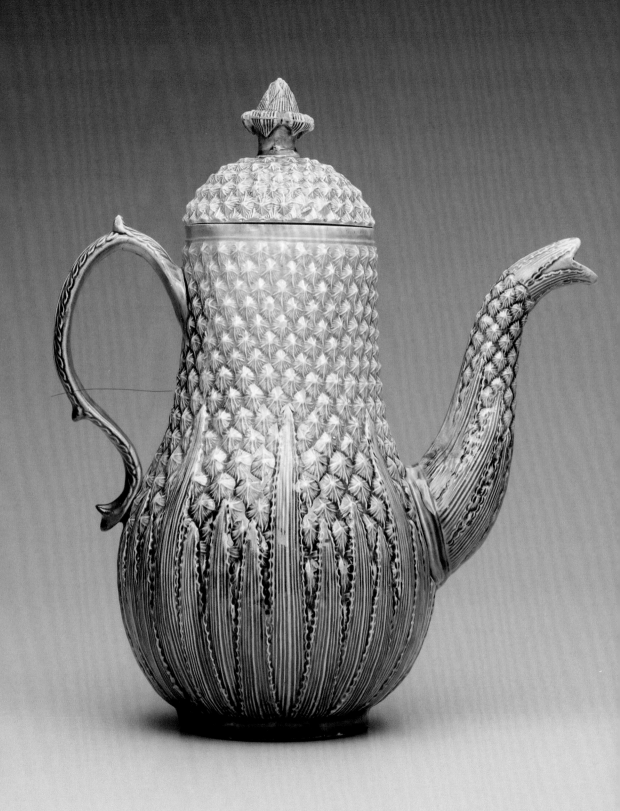

Coffee, Tea, and Chocolate

CONSUMING THE WORLD

YAO-FEN YOU

With essays by

Mimi Hellman and Hope Saska

DETROIT INSTITUTE OF ARTS

DISTRIBUTED BY
YALE UNIVERSITY PRESS,
NEW HAVEN AND LONDON

This catalogue was published in conjunction with the exhibition *Bitter|Sweet: Coffee, Tea, and Chocolate*, at the Detroit Institute of Arts, November 20, 2016–March 5, 2017

The exhibition was organized by the Detroit Institute of Arts. Support has been provided by the National Endowment for the Arts.

Library of Congress Cataloging-in-Publication Data

Names: You, Yao-Fen. | Hellman, Mimi, 1962- | Saska, Hope. | Detroit Institute of Arts, organizer, host institution.
Title: Coffee, tea, and chocolate : consuming the world / Yao-Fen You ; with essays by Mimi Hellman and Hope Saska.
Description: Detroit : Detroit Institute of Arts, 2016. | "This catalogue was published in conjunction with the exhibition Bitter/Sweet: Coffee, Tea, and Chocolate, Detroit Institute of Arts." | Includes bibliographical references and index.
Identifiers: LCCN 2016016417 | ISBN 9780895581747 (dia, publisher) | ISBN 9780300222500 (yale u.p., distributor)
Subjects: LCSH: Coffee—Social aspects—Exhibitions. | Tea—Social aspects—Exhibitions. | Chocolate—Social aspects—Exhibitions. | Coffee in art—Exhibitions. | Tea in art—Exhibitions. Classification: LCC GT2918 .C65 2016 | DDC 394.1—dc23
LC record available at https://lccn.loc.gov/2016016417

ISBN 978-0-89558-174-7 (Detroit Institute of Arts)
ISBN 978-0-300-22250-0 (Yale University Press)

Printed and bound in Italy

Director of Publishing and Collections Information: Susan Higman Larsen
Manager, Photography: Eric Wheeler
Permissions and photo research: Kimberly Long

Designed by Patricia Inglis, Inglis Design
Proofread by Mary Ellen Wilson
Index by David Luljak

Published by the Detroit Institute of Arts
www.dia.org

Distributed by Yale University Press, New Haven and London
www.yalebooks.com/art

FRONT COVER: Sèvres Porcelain Manufactory, *Tea and Coffee Service* (detail), 1842–43 (cat. 58); BACK COVER: Mayan culture, *Tripod Vessel with Slab Legs*, 300–600 (cat. 4); PAGES 2–3: Fürstenberg Porcelain Factory, *Tea and Coffee Service*, ca. 1760 (cat. 44); FRONTISPIECE: England (Staffordshire), *Pineapple Coffeepot*, ca. 1750 (cat. 26)

Contents

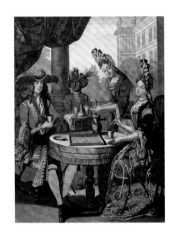

LIST OF LENDERS

Les Arts Décoratifs, Paris

Clark Art Institute, Williamstown, MA

Cooper Hewitt, Smithsonian Design
 Museum, New York

The Henry Ford Museum, Dearborn, MI

The Hispanic Society of America, New York

The Metropolitan Museum of Art, New York

Michigan State University Museum,
 East Lansing

The Morgan Library and Museum,
 New York

Musée du Louvre, Paris

Museum of Fine Arts, Boston

Toledo Museum of Art

University of Michigan, Special Collections
 Library and Harlan Hatcher Graduate
 Library, Ann Arbor

Private Midwest collection

Director's Foreword

It is difficult to imagine not starting the day with a steaming cup of freshly brewed coffee or a nice hot cup of tea, or maybe even a cup of thick hot chocolate, as some do in my native Spain, where it is served with a side of *churros*. What is Italy without its famous café-lined piazzas or an England without afternoon tea? Yet there was a moment in time when Europe was caffeine deprived and knew not of such beverages we have come to take for granted, if not live without—in my case, a *café con leche*.

The publication of this book accompanies an exhibition that retraces the story of how coffee, tea, and chocolate (and sugar)—all foreign to Europe—appeared on European tables starting in the late sixteenth century. The works of art assembled—ranging from rare examples of porcelain and metalwork to important paintings, prints, and sculpture—demonstrate the tremendous impact of these once "exotic" drinks on European drinking habits; social customs; attitudes toward health, commerce, and manufacturing (particularly the ceramics industry); and even national identities. Such beverages not only stimulated the body and mind, but also the desire for colonial expansion. The exhibition grew directly from the Detroit Institute of Arts' diverse and rich holdings in works—western and nonwestern—associated with the service and consumption of coffee, tea, and chocolate. The emphasis, though, is on objects from eighteenth-century Europe.

The exhibition and publication that accompanies it were planned under the leadership of my predecessor Graham W. J. Beal. Thanks are due to Yao-Fen You, associate curator of European Sculpture and Decorative Arts, who conceived the exhibition and was the principal author of the catalogue. We wish to acknowledge all our lenders, both institutional and private, for their enormous generosity to this project. Finally, we are grateful for the generous support we have received from the National Endowment for the Arts.

SALVADOR SALORT-PONS
Director, Detroit Institute of Arts

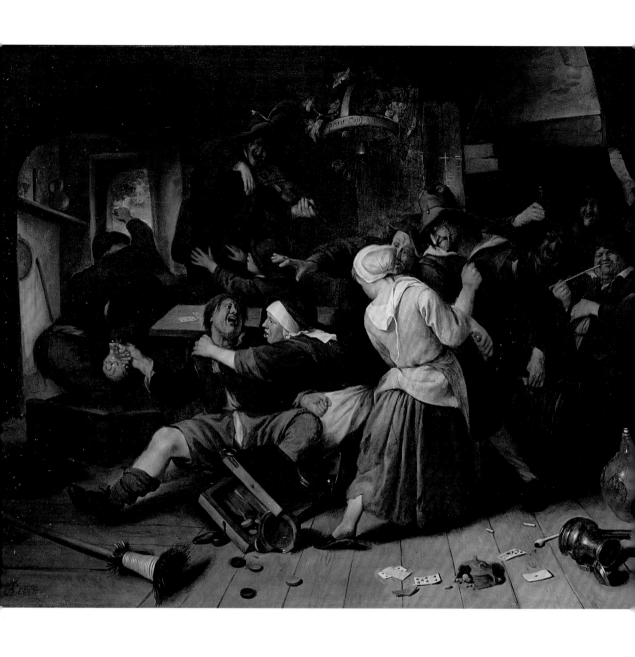

YAO-FEN YOU

From Novelty to Necessity: The Europeanization of Coffee, Tea, and Chocolate

COFFEE, TEA, AND CHOCOLATE were strongly associated with Enlightenment Europe as the era's most fashionable beverages. Over the course of the eighteenth century, the consumption of coffee grew from 2 million to 120 million pounds, tea from 1 million to 40 million pounds, and chocolate from 2 million to 13 million pounds.[1] Yet none of the plants required for the preparation of these novel stimulant drinks were native to Europe. They arrived from corners of the globe newly inscribed into the European imagination — the Levant (coffee beans), Asia (tea leaves), and Mesoamerica (cacao beans).

Each of these exotic edibles arrived in Europe in very different ways, but all were initially touted for their health benefits and medicinal purposes, and virtually promoted as cure-all drugs. In 1657 an English advertisement for coffee praised its "many excellent vertues." Among other things, coffee "closes the Orifice of the Stomack, fortifies the heat within, helpeth Digestion, quickneth the Spirits, maketh the heart lightsom, is good against Eye-sores, Coughs, or Colds, Rhumes, Consumptions, Head-ach, Dropsie, Gout, Scurvy, Kings Evil, and many others...."[2] Such rhetoric was reinforced by scientists and doctors alike. The Amsterdam physician Nicolaes Tulp, in 1652, noted that tea not only enlivened the body, "but it also wards off painful stones, from which, they say, no one here suffers. Indeed, it counters headache, cold, inflammation of the eyes, drooping or disturbing of the spirits, weakness of the stomach, intestinal dysentery, lassitude, and sleep, which it so evidently checks." Most notably, "sipping this decoction, one may sometimes spend entire nights working, without any troubling effects, and without being otherwise overcome by the need for sleep."[3] Such wondrous claims about chocolate had been made earlier in 1631 by Antonio Colmenero de Ledesma, a Jesuit missionary with a degree in medicine and author of *Curioso Tratado de la naturaleza y calidad del Chocolate,* which

Cat. 1. Jan Steen, *Gamblers Quarreling,* ca. 1665

was translated into English by army captain James Wadsworth in 1640. The English-speaking world learned in the very first paragraph that this "wholesome" drink, already in great use in the Indies and the courts of Spain, Italy, and Flanders, "strengthens the stomacke." As he later explained:

> And though it be true, that, in the *Indies,* they use it all the yeare long, it being a very hot Countrey, and so it may seeme by the same reason it may be taken in *Spaine:* First, I say, that Custome may allow it: Secondly, that, as there is an extraordinary proportion of heat, so there is also of moisture; which helpes; with the exorbitant heate, to open the pores; and so dissipates, and impoverisheth our substance, or naturall vigor: by reason wherof, not only in the morning; but at any time of the day, they use it without prejudice. And this is most true, that the excessive heate of the Countrey, drawes out the naturall heat, and disperseth that of the stomacke, and of the inward parts: Insomuch, that though the weather be never so hot, yet the stomacke being cold, it usually doth good.[4]

With their stimulant properties, these new drinks were welcomed as sobering alternatives to alcohol, particularly beer—that favored, quintessential European beverage. Too much drink often led to associated social ills, such as gambling and fighting (cat. 1); in this context, coffee was favored as an aid to sobriety. As the Lyon pharmacist Philippe Sylvestre Dufour, author of *Traitez nouveaux & curieux du café, du thé et du chocolate* (cat. 2), reported: "Coffee sobers you up instantaneously, or in any event it sobers up those who are not fully intoxicated."[5] It was through early modern manuals such as *Traitez nouveaux & curieux du café, du thé et du chocolate*—first published in 1671 and updated in 1685—that the three drinks came to be grouped as a trinity of tonics in the European imagination.[6]

The new hot drinks were not embraced by all. The Princess of Palatine, Charlotte Elizabeth, detested the new hot beverages, preferring instead her native beer. Writing to Raugravine Louise [Louise von Degenfeld] on 8 December 1712, she proclaimed: "I cannot bear tea, coffee, or chocolate, and cannot understand how any one [*sic*] can like that sort of thing. I find that tea tastes of hay and rotten straw, coffee of soot, and chocolate is too sweet and soft. What I would willingly partake of would be a good dish of Biran brot, or beer soup; these things would do no harm to one's inside...."[7] Other detractors included health-conscious physicians such as George Cheyne. An early advocate of

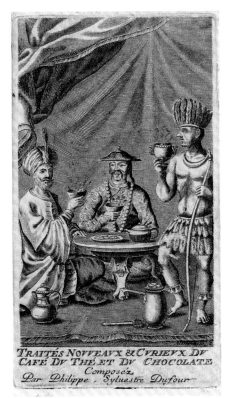

Cat. 2. Philippe Sylvestre Dufour, *Traitez nouveaux & curieux du café, du thé et du chocolate*, 1688

Cat. 3. *A True Report of the Great Sermon that Mahomet Calipapau, of Russian nationality, the Great Prior of Escanzaona, and the Archbishop of Lepanto, Doctor Degreed in the Texts and Paragraphs of the Koran preached in the Parroquial Mosque of Babylon*, 1684

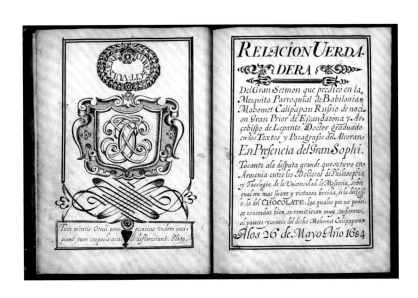

vegetarianism, he called for the use of tea and coffee in moderate amounts, but declared chocolate wholly impossible to digest and "too hot and heavy for valetudinary persons; and those of weak nerves."[8] Cheyne deemed coffee taken with milk permissible if consumed in moderation, particularly by those in cold climates; in excess, "this Moahometan Custom" turned people "stupid, feeble, and paralitick."[9]

Not surprisingly, the medical claims made for the beverages, as well as the appropriate terms of their consumption, were the subject of heated theological and political debates: Who could consume them? How many cups was considered adequate or excessive? Was it appropriate for a priest "to interrupt his Mass to guzzle chocolate?"[10] Their consumption was also a battleground for early modern battles of the sexes. The 1674 pamphlet "Women's Petition Against Coffee"—a response to the exclusion of women from early coffeehouses—claimed that coffee rendered men impotent. Johann Sebastian Bach's one-act comic operetta *Ach wie ist der Kaffee süße* (1732), also called the "Coffee Cantata," responded to fears of sterility that excessive coffee might produce in women of child-bearing age.[11] Chocolate's reputed panacean properties, such as the ability to revive the dead, were appropriately skewered in an unpublished (and unpublishable) anonymous 1684 poem titled "A True Report of the Great Sermon that Mahomet Calipapau, of Russian nationality, the Great Prior of Escanzaona, and the Archbishop of Lepanto, Doctor Degreed in the Texts and Paragraphs of the Koran preached in the Parroquial Mosque of Babylon"(cat. 3).[12]

CHOCOLATE

Chocolate was the first of the three to arrive in Europe. Spain came upon chocolate, or cacao, as early as 1502, when Christopher Columbus on his fourth visit to the "New World" captured a Maya trading canoe at Guanaja Island of Honduras. The cargo of the canoe included cacao beans, which the Amerindians had been harvesting for at least a thousand years before Columbus had reached the New World. Left whole, the prized cacao beans functioned as currency throughout the Aztec world and had special vessels in which they were stored (cat. 4). Roasted and ground into a paste, perhaps thickened with maize and sometimes spiced with chili peppers and fragrant flowers but always mixed with water, the cacao bean was transformed into a ritual beverage for the elite and served in sacred vessels that were consecrated by painted dedication formulas on the exterior (cat. 5).[13] It was not until 1544 that cacao was introduced into

Spain, at the court of Phillip II, and only in 1585 that the first legal commercial shipment of cacao to Europe was sent from Veracruz to Seville.[14]

Chocolate was slow to spread to the rest of Europe, and it was not until the second half of the seventeenth century that it started to penetrate the Northern European courts, seducing the French aristocrats at Versailles and German courtiers in Hanover. While chocolate had already reached parts of France in the seventeenth century, courtesy of the Jewish merchants at Bayonne, we can credit the Infanta Maria Theresa of Spain (1638–83) with spreading its popularity at the French court (cat. 6). With her marriage to Louis XIV in 1660, it was said that the queen had two passions: chocolate and the king. Maria's sister-in-law, Charlotte Elizabeth, the Duchesse d'Orléans, reported that the queen's "ugly black teeth came from her eating too much chocolate. She was also very fond of garlic."[15] Shortly after Maria Theresa's move to France, the position of a chocolatier was introduced at the court. Chocolate receptions—hosted three times a week by Louis XIV—soon followed, but ended in 1693 due to financial difficulties.

Around the same time that chocolate was achieving traction at the French court, the British were also learning about the wondrous effects of chocolate. By 1657, an enterprising Frenchman was making chocolate, both prepared and unprepared, available to Londoners: "In Bishopsgate Street, in Queen's Head Alley, at a Frenchman's house, an excellent West Indian drink called chocolate to be sold, where you may have it ready at any time, and also unmade at reasonable rates."[16]

Apart from its reputed digestive qualities, chocolate was particularly prized as an aphrodisiac in the early modern European mind. As Wadsworth noted in the introduction to the 1652 edition of his translation, chocolate "vehemently Incites to Venus, and causeth Conception in women, hastens and facilitates their Delivery."[17] Madame de Pompadour supposedly confessed to her friend, the older duchesse de Brancas, that "she had consequently, she said, begun to consume substances (truffles, chocolate, aphrodisiac drinks) that she hoped would warm her up."[18] Chocolate's supposed sexual side effects were of great interest to Enlightenment artists. Both Jean-Baptiste Le Prince's *Fear* (cat. 7) and Robert Bonnart's *Un cavalier, et une dame beuvant du chocolat* (cat. 8) invite viewers to ponder chocolate's guise as an erotic stimulant.[19] In spite of the chaotic setting, the woman's state of undress, and the missing lover, it appears that chocolate fueled some of the amorous intrigue of the moments before, as

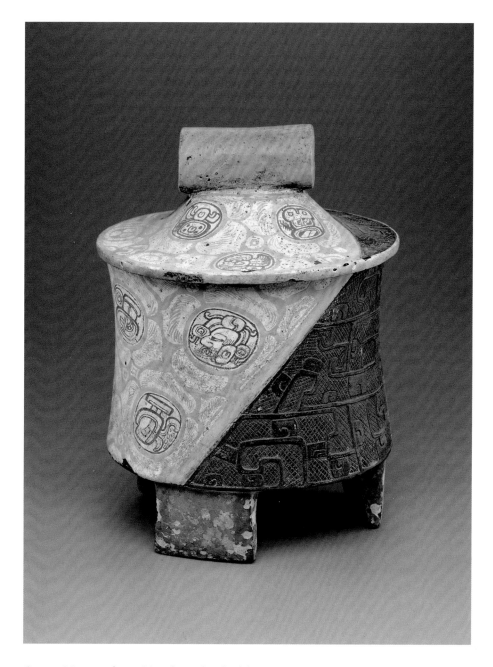

Cat. 4. Mayan culture, *Tripod Vessel with Slab Legs*, 300–600

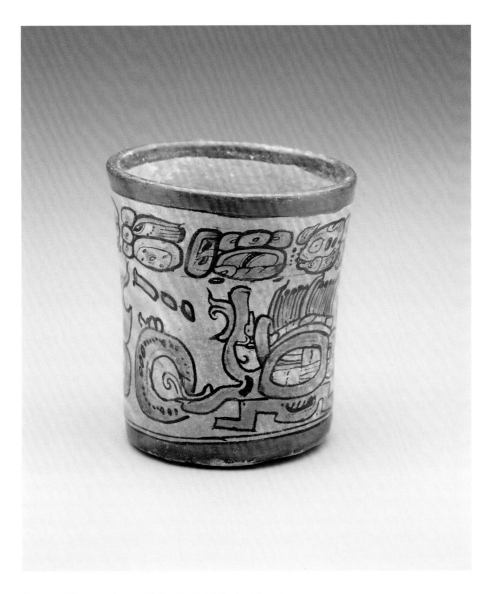

Cat. 5. Mayan culture, *Codex Style Cylinder Vase*, 600–900

visibly suggested by the chocolate pot with its clearly denoted chocolate mill and the two chocolate cups on the side table next to her bed. In Bonnart's print, the inscription combined with the composition leaves no doubt in the viewer's mind that the enjoyment of chocolate (*se regalent de Chocolat*) between "this young gentleman and this beautiful lady" (*Ce jeune Cavalier, et cette belle Dame*) is helping to induce the "spark in their eyes" (*leurs yeux une si vive flame*), which "requires an even more delectable dish" (*Qu'on croit qu'il leur faudroit un mets plus délicat*). Related to chocolate's capacity to incite *amor* was its role as a restorative, as emphasized by the inscription on the saucer of the neoclassical style Buen Retiro boxed set of chocolate cups (cat. 9): "for life" (*por la vida*).

TEA

Next came tea. In 1610, the Dutch East India Company (Vereenigde Oost-Indische Compagnie, or VOC) brought over the first shipment of tea to Europe through Amsterdam (cat. 10)—at least a thousand years after tea had become an item of common use in China. Ironically, that first shipment came not from China but Japan (cat. 11), where it had been in use from at least the ninth century.[20] It was in Venice that the first written record of tea occurred, mentioned briefly in the *Delle Navigazioni et viaggi* (1550–59) by the Venetian magistrate Giovanni Battista Ramusio. By the 1640s, the VOC had regularized the trade of Chinese tea, but they ultimately lost their dominance to the East India Company (EIC), which was successful in establishing a regular trade with Canton by 1717.[21]

Although they were slow to catch up to the fashion—Great Britain was one of the major coffee consumers in Europe at the beginning of the eighteenth century—the British embraced tea like no other European nation. Tea is such a defining symbol of British identity—what could be more British than a cup of (sweet) tea—it may come as a surprise to learn it owes much of its popularity to a foreign princess—the Portuguese Catherine of Braganza, the queen-consort of Charles II of England. Although Catherine by no means introduced tea to Britain—there is evidence of occasional tea sales in England from as early as 1635—she played her part in spreading the habit for tea drinking at court. A frequently told story holds that when the princess arrived in Portsmouth on 13 May 1662 after a long and stormy crossing from Portugal, she immediately asked for a cup of hot tea to calm her nerves. As tea was foreign to the British at this time, the poor princess was offered a glass of ale

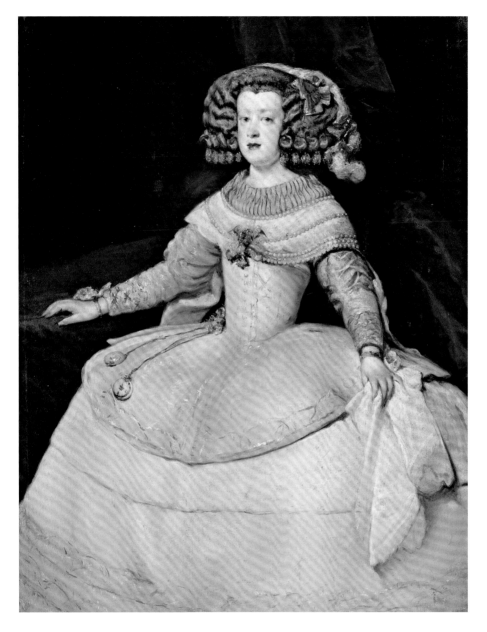

Cat. 6. Workshop of Diego Rodríguez de Silva y Velázquez, *Infanta Maria Theresa*, 1653

instead, which made her symptoms worse. What we can establish as fact is that Catherine's dowry included not only the Portuguese colony of Bombay, but also a chest of tea leaves that bewildered the English court.

COFFEE

Coffee was the last to reach Europe, but not far behind tea. The earliest published description of coffee appears in 1582, in Augsburg physician Leonhard Rauwolf's travelogue *Aigentliche Beschreibung der Raiß inn die Morgenländerin*. Having traveled through the Near East in search of new herbal medicine supplies, he encountered coffee in Aleppo, which had been absorbed into the Ottoman Empire by 1516. There its consumption had spread from the Red Sea region throughout the course of the sixteenth century. But it was not until 1640 that the first commercial quantities of coffee, which was native to Ethiopia but

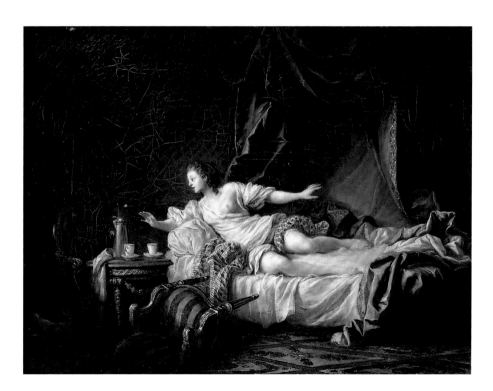

Cat. 7. Jean-Baptiste Le Prince, *Fear (La Crainte)*, 1769

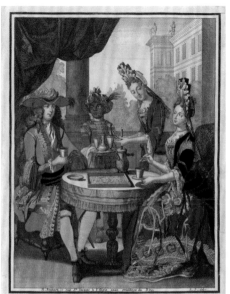

Cat. 8. Designed by Robert Bonnart, *Un cavalier, et une dame beuvant du chocolat*, 1690–1710

Cat. 9. Buen Retiro Manufactory, *Traveling Box with Cup and Saucer*, ca. 1800

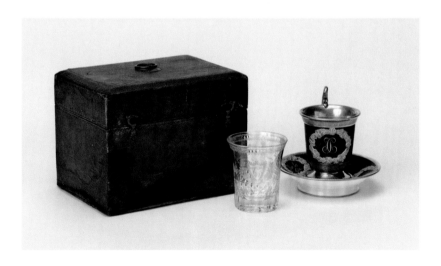

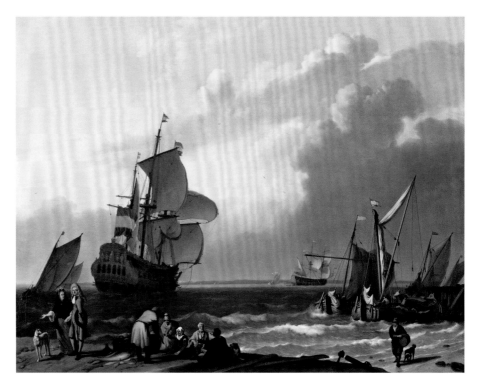

Cat. 10. Ludolf Backhuysen, *Coastal Scene with a Man-of-War and Other Vessels*, 1692

cultivated in Yemen, were brought to Europe through Venice, the center of a flourishing trade between local and Arab merchants (cat. 12). Venetian merchants sold this "Turkish drink" to the wealthy in Venice, charging them greatly for the privilege of drinking this exciting new beverage (cat. 13). By 1640, coffee of Yemen exceeded pepper as the main trading commodity of the Arabian Sea based at the port of Mocha (or, Al-Mukhā).[22]

Coffee's reputation as "the Turkish drink" (*Türckengetrank*) in spite of its Ethiopian origins was also perpetuated in eighteenth-century images, in paintings such as *La sultane (Madame de Pompadour as a Sultana)* by Carle van Loo (cat. 14). Both Madame de Pompadour and her lover Louis XV, who had coffee plants brought to Versailles so that they could be cultivated in the royal botanical garden, were great coffee enthusiasts. It is said that Louis most enjoyed his mistress on the occasions they were able to host informal but

Cat. 11. Japan, *Vessel for Hot Water,* late 15th–early 16th century

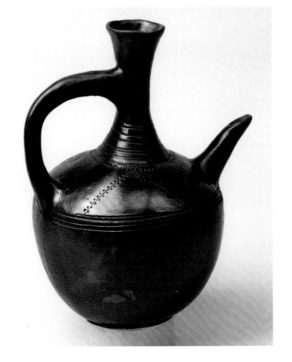

Cat. 12. Ethiopia, *Coffeepot (Jebena),* twentieth century

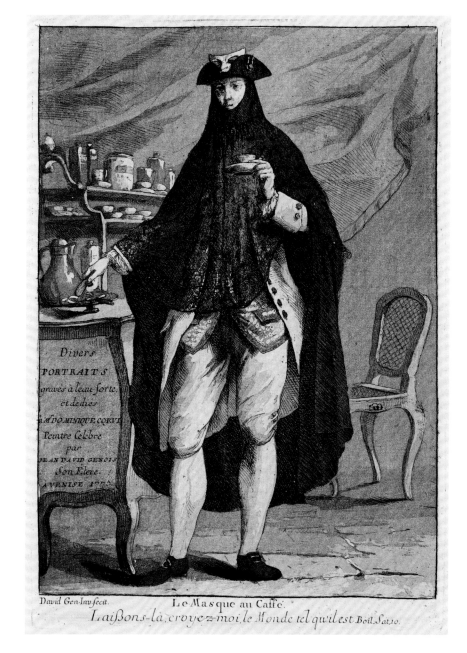

Cat. 13. Giovanni David, *A Man Wearing a Mask Drinking a Cup of Coffee*
(Le Masque au Caffè), 1775

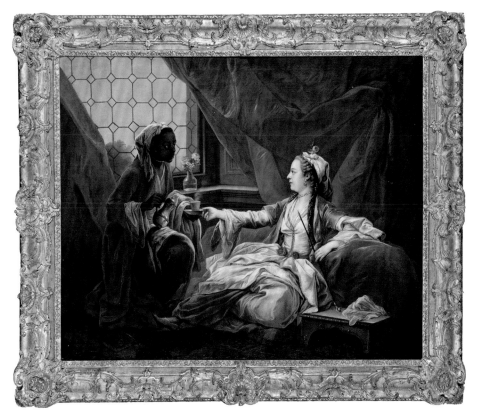

Cat. 14. Carle van Loo, *La sultane (Madame de Pompadour as a Sultana)*, 1755

intimate dinner parties (*petits soupers*) in the *Petits Appartements*, for which he was known to have made coffee for his guests himself—perhaps using Madame de Pompadour's personal coffee grinder (cat. 15).[23]

Coffee's strong association with the Levant—introduced as it was in 1669 by Mohammed IV's ambassador Suleiman Aga to the court of Louis XIV— helped coffee to capture the early modern French imagination. The consumption of coffee also helped to fuel fantasies of Turkey, with paintings such as Van Loo's participating in *turquerie*—"a European vision of the Ottoman Turkish world."[24] *Turquerie* prevailed as the fanciful visual idiom of fashionable interiors. Van Loo's painting, in fact, was one of three commissioned for display in Madame de Pompadour's Turkish bedroom at the chateau at Bellevue, where

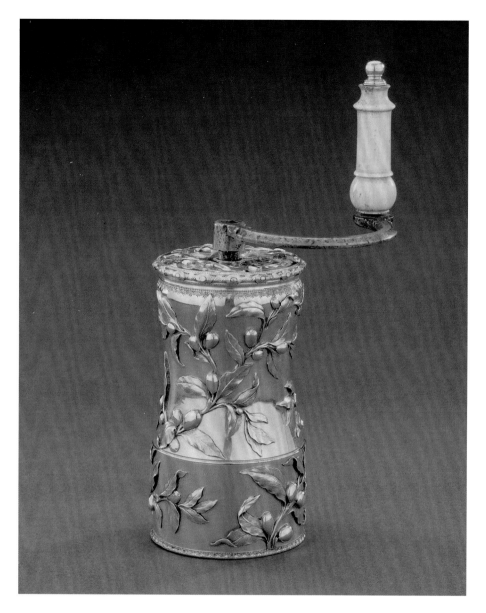

Cat. 15. Jean Ducrollay, *Coffee Grinder (Moulin à café)*, 1756–57

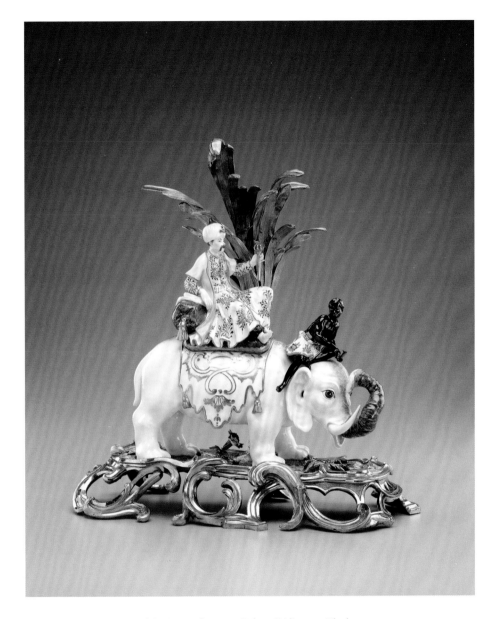

Cat. 16. Meissen Porcelain Manufactory, *Sultan Riding an Elephant*, ca. 1749

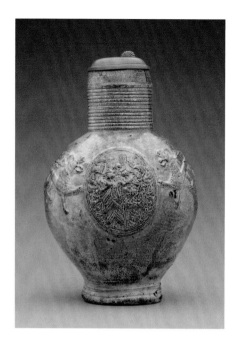

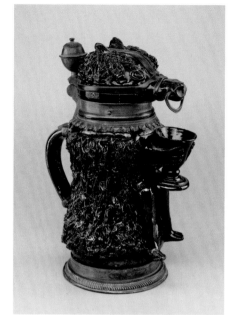

Cat. 17. Germany (Raeren), *Jug,*
1590/1600

Cat. 18. Germany or England, *Bear Stein,*
ca. 1750

Cat. 19. Germany (Siegburg), *Jug (Pulle)*
with Medallion of Helen of Troy, ca. 1586

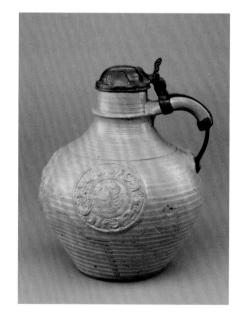

it would have interacted with exquisite mantel showpieces, such as the *Sultan Riding an Elephant* (cat. 16), to create a lavish, immersive "oriental" environment of complete European manufacture.[25]

NEW DRINKS, NEW WARES, NEW LANDS

The increased popularity in mid-seventeenth-century Europe of these caffeine drinks — paralleling the rise of a capitalist world economy — caused a near revolution in drinking habits, tastes, and social intercourse. Breakfast patterns changed profoundly, as did daily timetables. Instead of starting the day with alcohol (cats. 17–19), early modern Europeans could choose from one of the three hot drinks — a strong cup of coffee, a gentle cup of tea, or a nourishing cup of hot chocolate — to jump-start their mornings (cat. 20).[26] The rise of institutions such as afternoon tea increased opportunities for social contacts, while the establishment of public coffeehouses and cafes allowed different classes to intermingle.[27] Shifts in what defined polite behavior accompanied the new centers of sociability. The drinking and service of the novel beverages were at the center of "rituals of self-presentation and polite interaction through which privileged individuals crafted their social personas."[28] Thus, the consumption of coffee, tea, and chocolate played key roles in the making of emerging notions of respectability and gentility.[29]

The polite activity of tea drinking was celebrated in conversation pieces, a new type of group portraiture that developed during the late 1720s and early 1730s, primarily in England but also in France. In *The Strong Family* by Charles Philips (cat. 21) — one of the three most prolific painters of the genre — tea drinking is portrayed alongside card playing and gaming, other fashionable and refined social activities defining the polite society of eighteenth-century England.[30] Contemporary literary forms — poems, essays, and plays — also helped to consolidate its elite status.[31] The very influential early eighteenth-century journal *The Spectator*, published by Joseph Addison (cat. 22), was crucial in conceiving of the tea table as the site of polite conversation, especially for British women of propriety, cut off as they were from the masculine world of British clubs and coffeehouses.

The association of tea drinking with female domesticity also extended to the Netherlands, certain parts of Northern Germany, and France, where it was visually consolidated in works such as the print (cat. 23) after Jean-Siméon Chardin's 1735 painting *A Lady Taking Tea* (Hunterian Museum and Art Gallery,

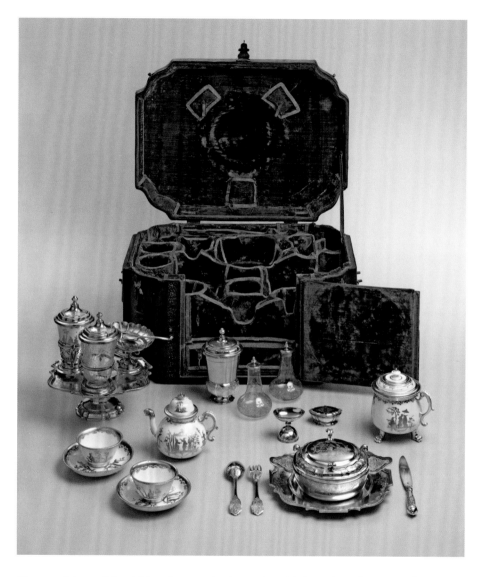

Cat. 20. Johann Erhard Heuglin II and other artists, Meissen Porcelain Manufactory, *Breakfast Set*, ca. 1728/29

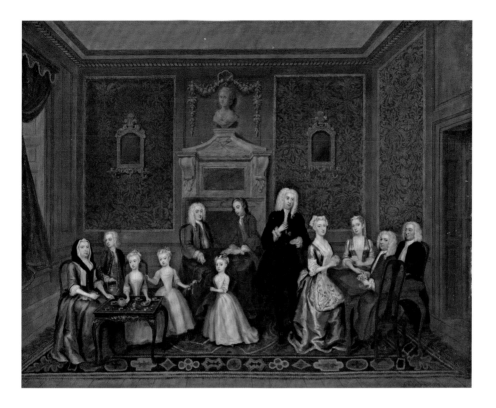

Cat. 21. Charles Philips, *The Strong Family*, 1732

Glasgow). Even without the inscription—*Dame prenant son thé*—it is evident that we are looking at an image of a fashionable Parisian lady enjoying a moment of respite while drinking tea from her imported porcelain wares.[32] The aristocratic ladies of eighteenth-century Germany preferred the strong brew of coffee, often hosting daily or weekly coffee circles (*Kaffeekränzchen*) in their salons (*Frauenzimmern*), while their men gathered in coffeehouses.[33] Unlike the British tea table, which reinforced strict social norms of politeness for women, the German coffee table offered women a new social framework for asserting their individuality, ultimately helping transform the status, the image, and the daily schedule of women in Germany.[34]

 The new beverages also spurred an insatiable demand for a range of fashionable and new equipage, including but not limited to coffeepots (cats.

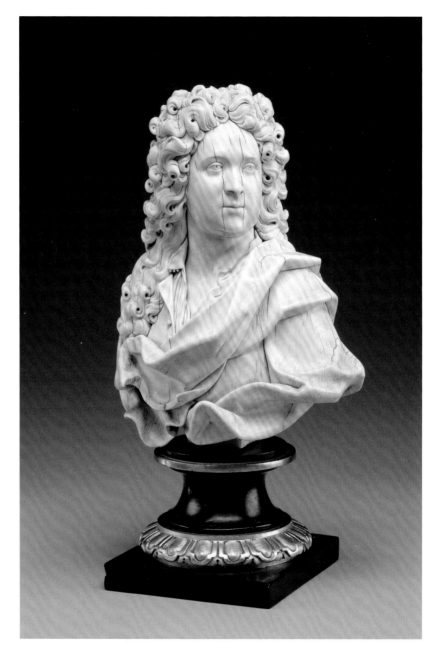

Cat. 22. David Le Marchand, *Bust of a Gentleman, possibly Joseph Addison,*
ca. 1707

Cat. 23. Pierre Filloeul, after Jean-Siméon Chardin, *Dame prenant son thé*, mid-eighteenth century

24–27), tea caddies (cats. 28–29), teaspoons and sugar nippers (cat. 30), choco-
late pots (cats. 31–32), and special chocolate cups and stands (cats. 33–35).[35]
The need for hot water urns (cat. 36), tea kettles (cat. 37), salvers (cats. 38–39),
and hot milk pots (cat. 40) favored the silversmith with increased orders, while
the desire for wares strong enough to withstand boiling water encouraged
the unprecedented expansion of domestic porcelain production (cats. 41–42).
Matching hot beverage sets quickly became a mainstay of European manufac-
tories, with Meissen (cat. 43), Fürstenberg (cat. 44), and Sèvres paving the way,
and Royal Worcester (cat. 45) and others (cat. 46) following suit. There was
also a need for furniture on which the services sat and from which they could
be served (cat. 47).

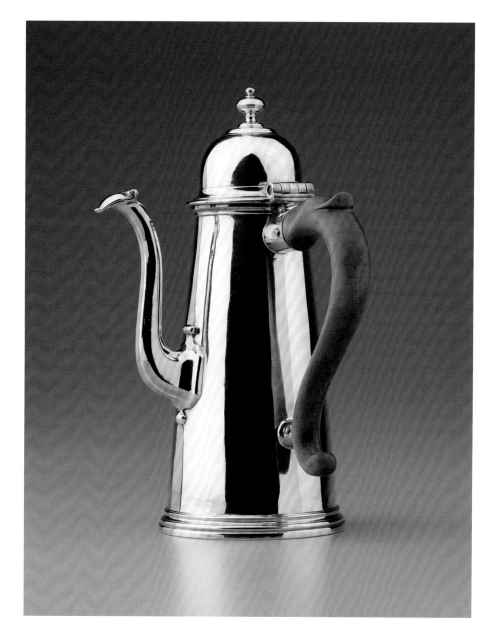

Cat. 24. John White, *Coffeepot*, ca. 1724

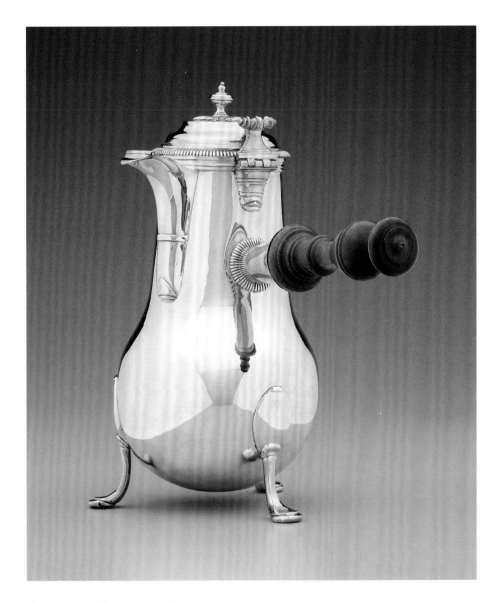

Cat. 25. Jean Beaucaire, *Coffeepot*, ca. 1724–25

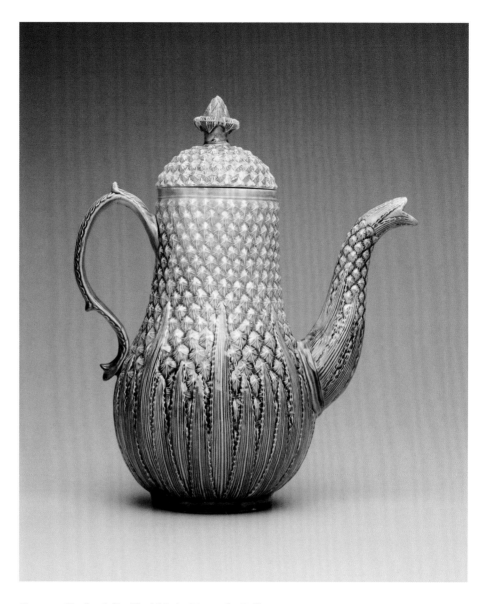

Cat. 26. England (Staffordshire), *Pineapple Coffeepot*, ca. 1750

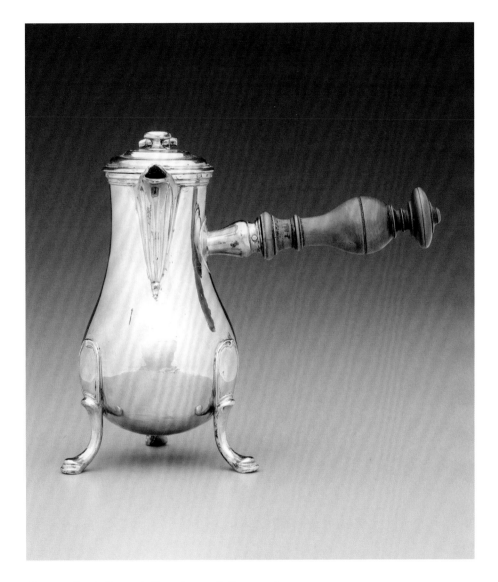

Cat. 27. Denis-François Franckson, *Coffeepot*, 1789

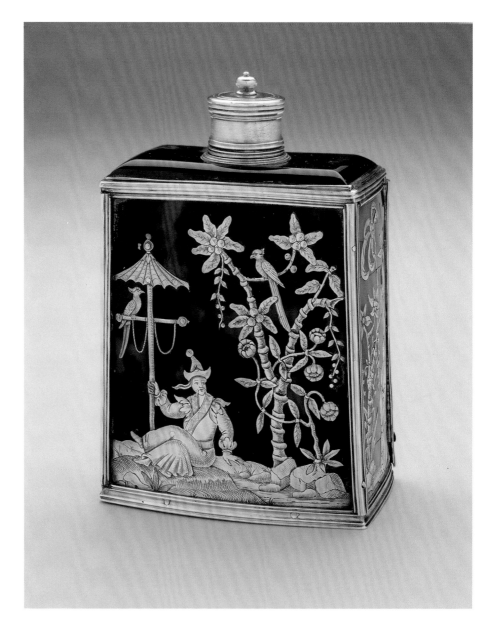

Cat. 28. Attributed to Hendrik Voet, *Tea Caddy*, ca. 1700

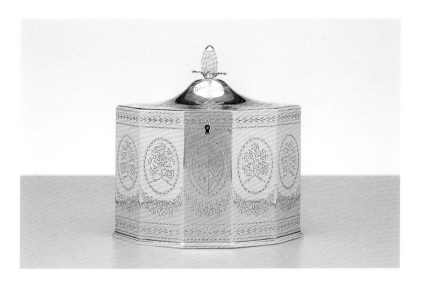

Cat. 29. Thomas Graham and Jacob Willis, *Tea Caddy*, 1789

Cat. 30. England, *Twelve Teaspoons, One Strainer Spoon, and a Pair of Sugar Nippers*, ca. 1750

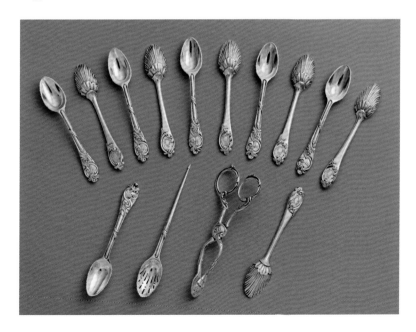

Cat. 31. Paul Crespin,
*Chocolate Pot with Swizzle
Stick*, 1738

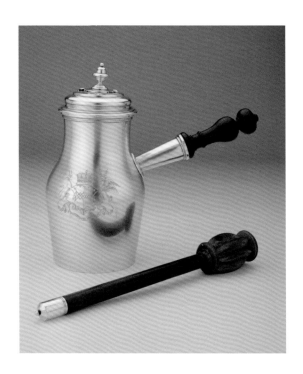

Cat. 32. Pierre Vallières,
Chocolate Pot, 1781

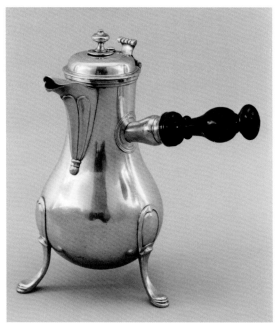

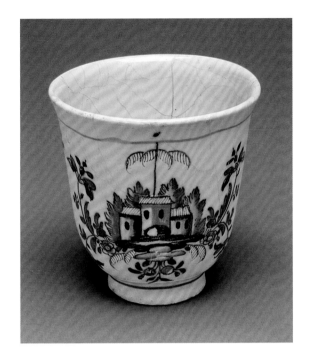

Cat. 33. Royal Factory of
Alcora, *Jícara* (chocolate cup),
1740–60

Cat. 34. Royal Factory
of Alcora, *Mancerina* (saucer
for chocolate cup), 1740–60

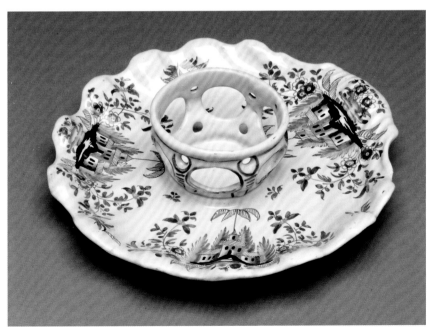

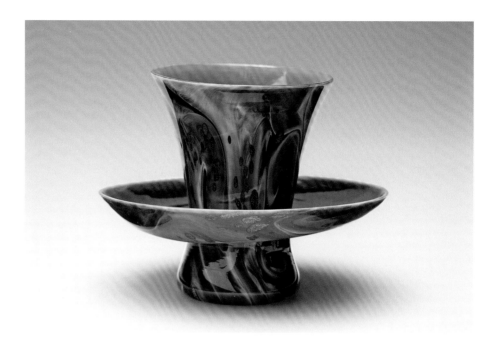

Cat. 35. Italy (Venice), *Calcedonio Cup and Saucer (Trembleuse)*, early eighteenth century

Not surprisingly, the forms of these new European paraphernalia took their design cues from the serving vessels used in their source cultures. The round squat forms of Chinese teapots were slavishly copied (cats. 48–51), while handles were added to Chinese tea bowls (cats. 52–53) and transformed into European tea and coffee cups with saucers (cats. 42–43, 54–55). British silver tea kettles, with top handles, approximate closely the Japanese lacquered wood hot-water vessels. The wooden stirrer (*moulinet; mouissoir; baton; baguette*) of the eighteenth-century chocolate pot (*chocolatière*)—very few of which survive—was a European adaptation of the Spanish colonial *molinillo*, or wooden beater, which was twirled with two hands through a hole in the closed top, as pictured in *Un cavalier, et une dame beuvant du chocolat* (cat. 8). Similarly, the Spanish *jícara* (or, *xícara*; cat. 33), made from earthenware, represents a material response to the Nahuatl *xicalli*, a lacquered calabash gourd from which Aztecs drank cacao. The irony of the Meissen coffee cup (cat. 56) made in imitation of a Turkish

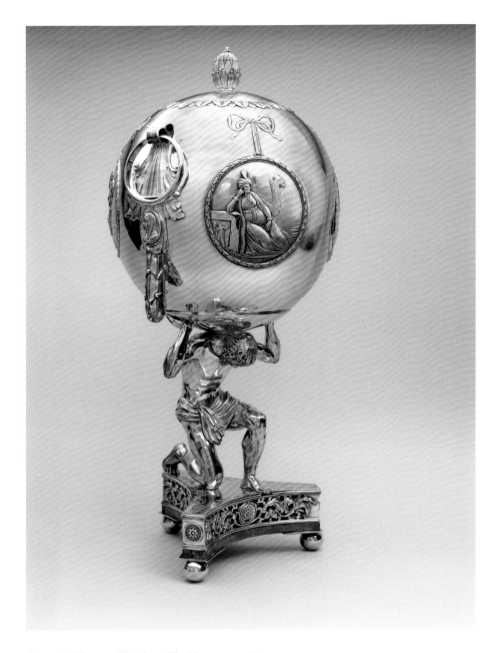

Cat. 36. Thomas Heming, *Tea Urn*, 1777–78

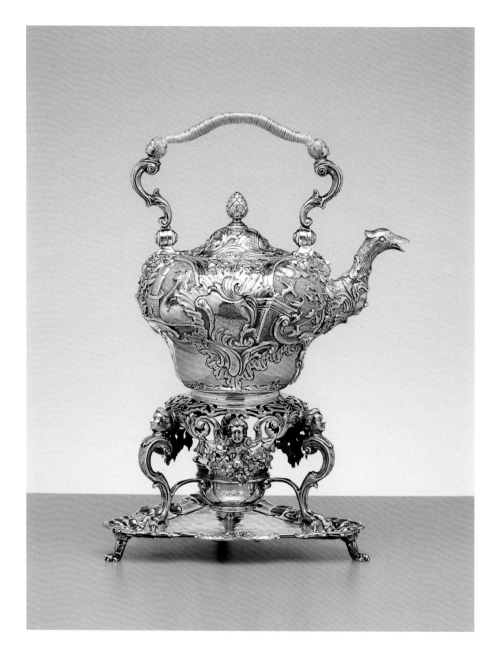

Cat. 37. Thomas Whipham the Elder, *Kettle and Stand*, 1740–48

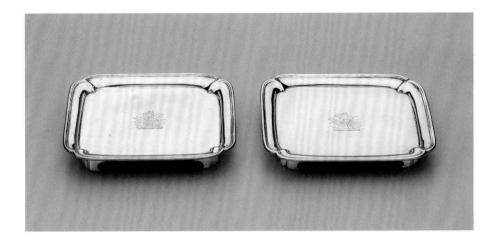

Cat. 38. Thomas Farren, *Pair of Waiters*, 1726/27

Cat. 39. Pezé Pilleau, *Footed Salver*, 1740

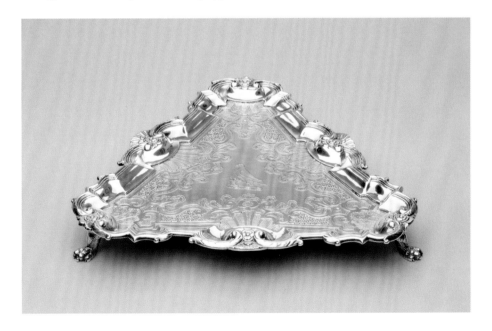

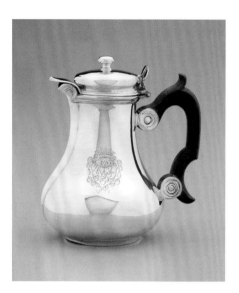

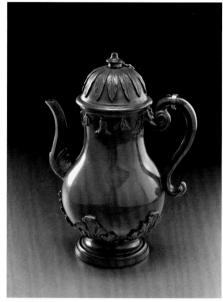

Cat. 40. Barthelemy Samson, *Hot Milk Pot*, ca. 1764

Cat. 41. Meissen Porcelain Manufactory, *Coffeepot*, 1710–15

(Kutahya) coffee cup, right down to the little red star painted on the base of the foot, is that the shape of such vessels started life as Chinese tea cups.

Tea's Chinese origins were alluded to over and over again in the paraphernalia associated with its consumption, from serving vessels (cats. 49–50) to storage containers (cat. 28). Early pieces by Saint-Cloud (cat. 54) and Staffordshire (cat. 48) sought directly to imitate Chinese export ware pieces (cat. 57), focusing on mastering the applied *prunus* decoration. Service and drinking vessels were decorated in the "Chinese taste" well into the first quarter of the nineteenth century (cat. 58), reinforcing the exotic origins of the drink, perhaps because of the monopoly over tea that China was able to maintain until 1830. Until the opening of China in the early 1800s, China remained essentially impenetrable to the West. Despite gaining direct access to the port of Canton in 1699, European trading houses in Canton were built outside the city walls

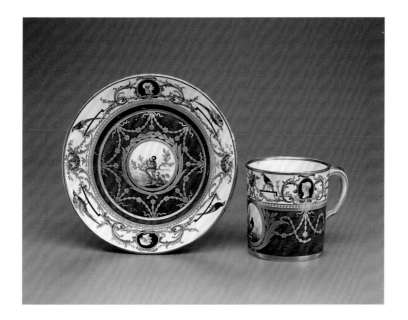

Cat. 42. Sèvres Porcelain Manufactory, *Cup and Saucer*, ca. 1785

Cat. 43. Meissen Porcelain Manufactory, *Pair of Quatrefoil Cups and Saucers*, ca. 1735

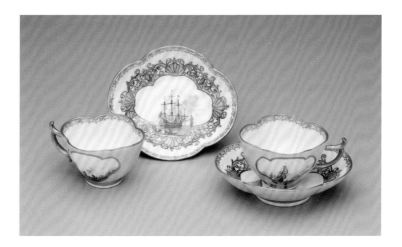

and Europeans were not allowed within the city. China's restrictive trading policies only served to heighten the mystery of the Orient in the European imagination, as visualized in the whimsical recasting of the Chinese emperor and his "courtiers" with European physiognomy and coloring in the sculptural grouping by the Höchst Manufactory (cat. 59) or the unlikely portrayal of Chinese people drinking tea off European cups and saucers on the reserves of Sèvres potpourri vases (cat. 60).

As these nonwestern drinks came to permeate everyday life to varying degrees, Europeans eventually sought to coopt the regional market for the product, if not eventually acquiring the tea plant (*Camellia sinensis*), the coffee shrub (*Coffea arabica*), or the cacao tree (*Theobroma cacao*) as part of their expanding empires in the Americas and Asia.[36] The Dutch introduced coffee to Java as early as the 1690s, and by the late 1720s, the Javanese exports had grown sufficiently in volume for the Dutch to withdraw from the Mocha trade. The French also benefited from the colonial endeavors in the Caribbean. By the 1730s, Antilles displaced Turkey as the principal source of French

Cat. 44. Fürstenberg Porcelain Factory, *Tea and Coffee Service*, ca. 1760

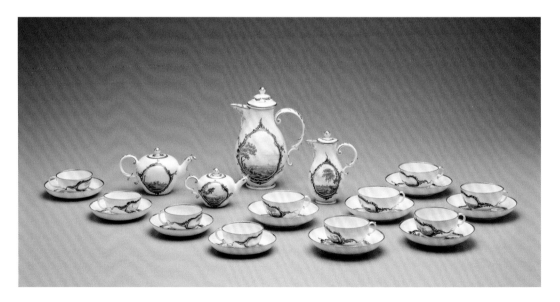

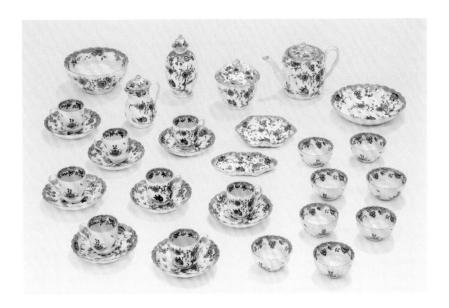

Cat. 45. Royal Worcester, *"Two Quail" Tea Service*, 1765–70

imports. The British were less successful in their attempts to farm coffee in Jamaica, where they introduced the plant in 1728 and produced the first export crop in 1737.[37] As Jordan Goodman has asserted, "achieving control over production and distribution was a key feature of the Europeanization of these exotic commodities."[38]

Colonial expansion—and the black slave labor on which it depended for its success—certainly made for lower prices and wider distribution of the caffeine beverages. The delicate but durable porcelain of Meissen and Sèvres, richly decorated with floral patterns, might shift attention from the horrific realities of labor involved in procuring its stimulating contents, but representations of turbaned black servants, or "blackamoors" (visual conflations of the notion of an Arab or Muslim with that of a black African), shown in conjunction with the service and consumption of the beverages cannot help but raise awareness—at least for the modern viewer (cats. 8, 16). At the same time, the liveried black servant in the Du Paquier crinoline group, *Lady at Her Breakfast* (cat. 61), functioned in the early modern era as a conspicuous index of wealth.

He is also a poignant reminder of the black slave labor that made possible the presumably sweetened drink in his mistress's hand and the sweetened pastries on the table next to her.

MILK AND SUGAR

The addition of milk and sugar—"that almost invisible sweet companion to our everyday drinks and meals"[39]—to these strong bitter brews was another way in which the exotic commodities were Europeanized, their foreignness domesticated, their vigor tamed, and their poison neutralized. Milk and sugar tempered the bitterness of the drinks. As some would argue, sugar was the quintessential colonial product. The Dutch—who had captured vast tracts of the Brazilian coastline from the Portuguese in the 1630s, including Olinda, a major center of the sugar cane industry (cat. 62)—were adding sugar to their

Cat. 46. Vienna Porcelain Manufactory, *Tea and Coffee Service*, ca. 1804

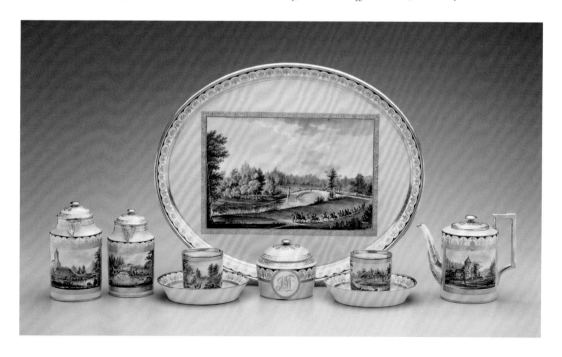

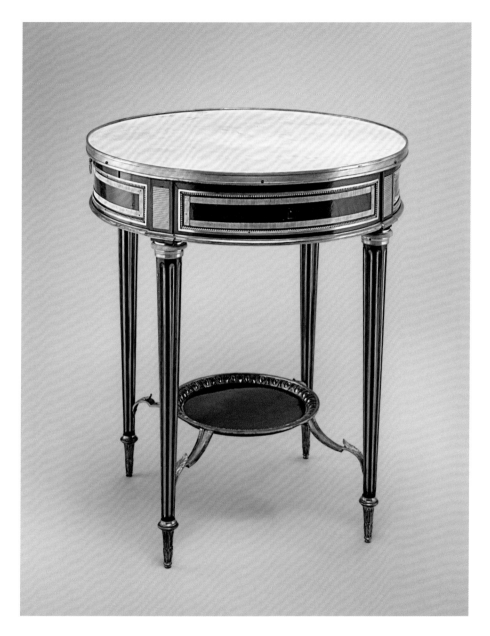

Cat. 47. Adam Weisweiler, *Combination Writing, Working, and Dining Table*, ca. 1785

Cat. 48. England (Staffordshire), *Teapot*, eighteenth century

Cat. 49. England (Staffordshire), *Teapot*, 1750

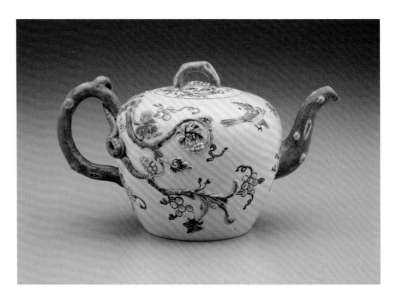

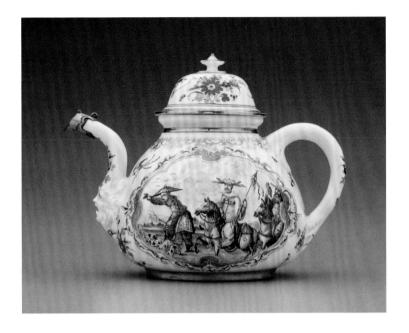

Cat. 50. Meissen Porcelain Manufactory, *Teapot*, 1723/24

Cat. 51. England (Staffordshire), possibly made by Whieldon Factory, *Teapot*, ca. 1750

Cat. 52. China, *Tea Bowl*, 960/1279

Cat. 53. China, *Cup Stand*, 1127–1279

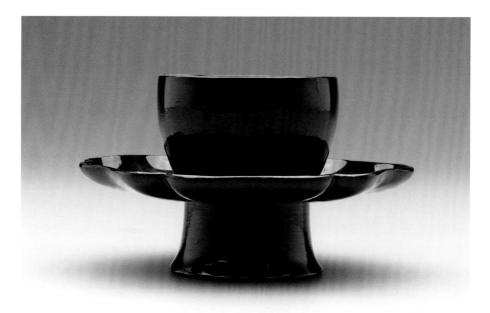

Cat. 54. Saint-Cloud Porcelain Manufactory, *Cup and Saucer*, ca. 1720

Cat. 55. Wedgwood, *Cup and Saucer*, ca. 1790

Cat. 56. Meissen Porcelain Manufactory, *Turkish Coffee Cup*, 1774/1814

Cat. 57. China (Dehua), *Wine Cup*, 1662–1722

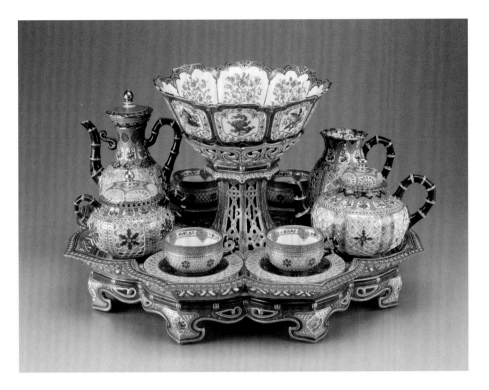

Cat. 58. Sèvres Porcelain Manufactory, *Tea and Coffee Service*, 1842–43

tea as early as the 1670s and 1680s. The Spanish and French were certainly in the habit of mixing sugar, if not milk, into their chocolate. For those observing Lent, chocolate made with water was considered acceptable to drink. Though the English initially drank tea in the Chinese fashion without milk, by 1700 the tempering of tea with milk or cream was quite common—a practice that necessitated teaspoons for mixing (cat. 30). By the 1750s, it was fashionable in England to add milk to tea, with more milk being added to tea than to coffee. Commercial dairying there, as a result, expanded greatly in the eighteenth century, as it did elsewhere (cat. 63).[40] Silver sugar boxes appear on tea tables as early as the late seventeenth century (cat. 64); by the middle of the eighteenth century, no service of tea or coffee was complete without a milk jug (cat. 65) or sugar bowl (cat. 66).

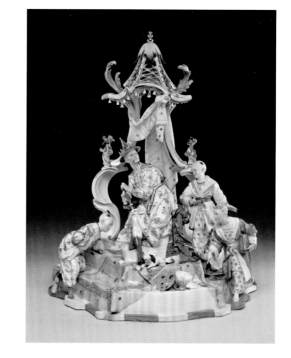

Cat. 59. Höchst Ceramics
Manufactory, *Audience of the
Chinese Emperor*, 1766

Cat. 60. Sèvres Porcelain
Manufactory, *Pair of Triangular
Potpourri Vases*, 1761

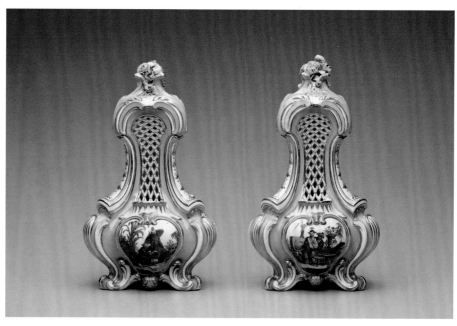

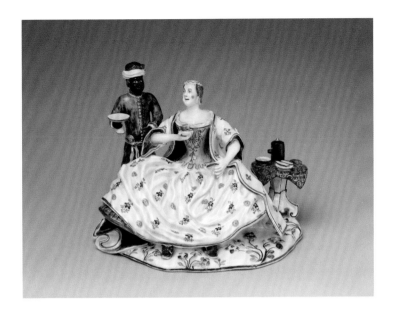

Cat. 61. Du Paquier Porcelain Manufactory, *Lady at Her Breakfast*,
1737–44

Cat. 62. Frans Post, *View of the Jesuit Church at Olinda, Brazil*, 1665

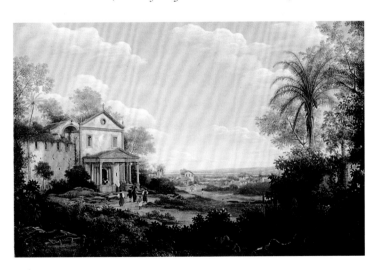

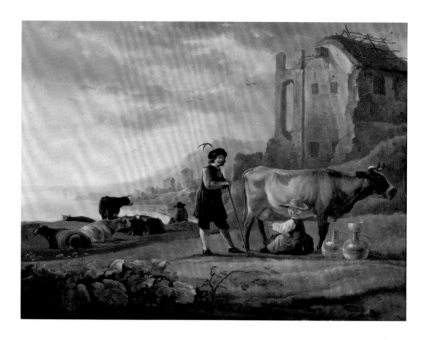

Cat. 63. Aelbert Cuyp, *Landscape with Maid Milking a Cow*, ca. 1655

Cat. 64. England (London), *Sugar Box*, 1678

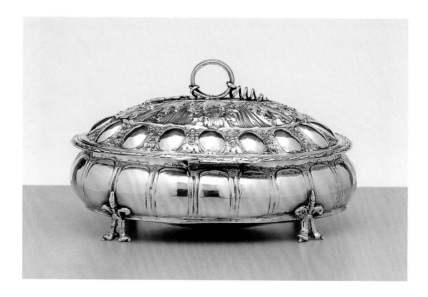

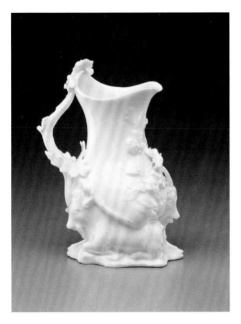

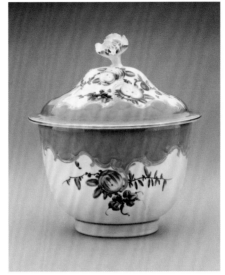

Cat. 65. Chelsea Porcelain Manufactory,
Goat and Bee Jug, 1745/49

Cat. 66. Royal Worcester, *Sugar Bowl*,
ca. 1770

Sugar had been introduced to Europe as early as the medieval period,
but it was initially regarded as a precious spice and preservative. Like the "new
hot drinks," sugar arrived in Europe with a reputation as a medicine. By the
baroque period, it was discovered that sugar in powder form could be mixed
with gum paste and the resulting plasticine-like material could be shaped
into buildings or impressive animals. Such sugar sculptures formed the basis
for elaborate table displays that announced one's status.[41] It was not until the
mid-eighteenth century that sugar found its true calling as a sweetener. Sugar
helped make the strong brews palatable, while the brews, in return, created the
foundation of its demand as a sweetener. Some have argued that the brews only
took because of the addition of sugar. In England, the most explosive growth in
sugar consumption—more than 40 percent in a decade—coincided with the
emergence of tea drinking. Sugar tongs were also an indispensable item of the
British tea table, physically reinforcing the British habit of taking tea with sugar
(cat. 30).

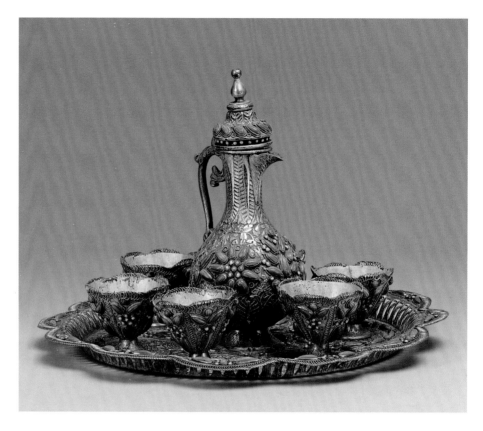

Cat. 67. Turkey, *Coffee Service*, nineteenth century

The addition of milk, especially hot milk (cat. 40), to coffee also helped to account for coffee's popularity in France, home of the *café au lait*. Milk, a domestic product that was very much part of the European palate, made the taste more bearable by mitigating the bitterness. And not only did milk significantly change the flavor profile of the alien brew—drunk black and bitter in the Ottoman Empire—it also changed the color, transforming it from dark muddy brown to light shades of taupe. In short, milk functioned to domesticate the exotic qualities of the "Turkish" drink. This "whitening" served to neutralize any dangers that the "Turkish drink," strongly associated with Islam, Arabia, and the Ottoman Empire (cat. 67), might pose by domesticating its exotic qualities.

CONSUMING COFFEE, TEA, AND CHOCOLATE TODAY

Coffee, tea, and chocolate continue to exert a powerful grip over the European psyche. Europe remains among the predominant consumers of coffee. A 2013 study of the top fifty coffee-consuming countries by the market intelligence agency Euromonitor—estimated per capita consumption of the dry weight of coffee (measured in metric ton)—found that nine of the top ten were in Europe: Finland, Norway, Netherlands, Slovenia, Austria, Serbia, Denmark, Germany, and Belgium. Brazil came in at number ten. Another data set by DataHero, based on cups per day per capita, has the Netherlands at the top, followed by Finland, Sweden, Denmark, Germany, Slovakia, Serbia, Czech Republic, and Poland. DataHero has also determined that the overall largest buyers of coffee worldwide are the United States (971 metric ton), Brazil (969 metric ton), and Germany (425 metric ton), followed by Italy (211 metric ton) and France (202 metric ton).[42] Either way, the statistics indicate that coffee is no less appealing now than it was in the eighteenth century.

As for the Asian leaf that seduced all of British society and is now the world's most popular drink after water, Ellis, Coulton, and Mauger have wryly observed that "corporatized and ubiquitous, tea is now normal, quotidian, regular, unexceptional."[43] According to their calculations, of the 1.16 trillion cups of tea brewed globally per annum (2013), 955 cups can be attributed to each person in Britain. This might change over the next decade with the rise of a global coffee culture. Economists report with great regularity that some of the fastest-growing coffee markets in the world are traditional tea-drinking markets like the United Kingdom.

Chocolate continues to lure taste buds, but in solid form instead of liquid. Thanks to Dutch chemist Coenraad van Houten, who in 1828 patented his method for separating cocoa butter from processed cacao, the road was paved for the production of creamy, solid chocolate as we know it. Again, Europeans outpace other parts of the world. A recent study estimates that eight of the top ten of the world's biggest chocolate consumers are European countries: Switzerland, Germany, Ireland, United Kingdom, Norway, Sweden, Australia, Netherlands, United States, and France.[44] The sources of chocolate have also dramatically shifted. Although cocoa beans were discovered in the Americas, about two-thirds of the world's cocoa is produced in West Africa.

NOTES

1. Jordan Goodman, "Excitantia: Or, how Enlightenment Europe took to soft drugs," in *Consuming Habits: Drugs in History and Anthropology*, edited by Jordan Goodman, Paul E. Lovejoy, and Andrew Sherratt (London, 1995), 126.

2. As quoted in William H. Ukers, *All About Coffee* (New York, 1922; reprint ed. 2015), 70.

3. As quoted in Markham Ellis, Richard Coulton, and Matthew Mauger, *Empire of Tea: The Asian Leaf That Conquered the World* (London, 2015), 34.

4. James Wadsworth, *A curious treatise of the nature and quality of chocolate. Written in Spanish by Antonio Colmenero, doctor in physicke and chirurgery. And put into English by Don Diego de Vades-forte* (London, 1640), 20. For further discussion, see Christine Jones, "When Chocolate was Medicine: Colmenero, Wadsworth, and Dufour," *Public Domain Review* 28 (January 2015). http://publicdomainreview.org/2015/01/28/when-chocolate-was-medicine-colmenero-wadsworth-and-dufour/[accessed April 26, 2016].

5. Dave Dewitt, *Precious Cargo: How Foods from the Americas Changed the World* (Berkeley, 2014), 139–40.

6. Christine Jones, "Exotic Edible: Coffee, Tea, Chocolate, and the Early Modern French How-to," *Journal of Medieval and Early Modern Studies* 43, no. 3 (fall 2013): 623–53.

7. Charlotte-Elisabeth Orléans (duchesse d'), *Life and Letters of Charlotte Elizabeth: Princess Palatine and mother of Philippe d'Orléans,*

regent for France 1652–1722 (London, 1889), 205–6. The original German: "Ich kan weder thé, caffé, noch chocolatte vertragen, kan nicht begreiffen, wie man es gern drinckt. Thé kompt mir vor wie heü undt mißt, caffé wie ruß undt seigbounen, undt chocolate ist mir zu süs....Was ich aber woll eßen mögte, were eine gutte kalteschal oder eine gutte biers."

8. George Cheyne, *An Essay of Health and Long Life* (London, 1724), 64.

9. Ibid., 61.

10. Marcy Norton, *Sacred Gifts, Profane Pleasures: A History of Tobacco and Chocolate in the Atlantic World* (Ithaca and London, 2008), 250.

11. Bennett K. Weinberg and Bonnie K. Bealer, *The World of Caffeine: The Science and Culture of the World's Most Popular Drug* (London and New York, 2001), xii, 87.

12. Norton 2008, 253–55. The manuscript has also recently been edited in full and published: Anonimo judio, *Chocolate e Inquisicion en un manuscrito satirico sefardi. Relacion verdadera del gran sermon. Edicion y studio*, edited by Mabel Gonzalez Quiroz, with introduction and notes (Barcelona, 2015). My thanks to John O'Neil for the reference.

13. The dedication formula on DIA 1990.298 reads as follows: "Here it is being written the drinking vessel for the fruit of the cacao tree...of Sak." I am grateful to Prof. Dr. Nikolai Grube for the transliteration, the transcription, and translation of the dedication formula. Nikolai Grube to Yao-Fen You, email, 20 September 2015. For more on the preparation of cacao, see Norton 2008, 16–18, 167–70.

14. Dewitt 2014, 118–21.

15. Full quote: "Our Queen was silly, but the best and most virtuous woman in the world. She always believed all that the King told her, true and false. It was said that her ugly black teeth came from her eating too much chocolate. She was also very fond of garlic. She was stout and little in height, with a very white skin. When neither walking nor dancing she looked tall. She eat [*sic*] frequently, but only a little each time, like a canary bird. She retained many Spanish ways and notions. She was extremely fond of gambling, preferring *bassette, reversi*, and *hombre*, but she could never win, not having been taught to play properly."

16. Louis E. Grivetti, "Chocolate: A Timeline," in *Chocolate: History, Culture, and Heritage*, edited by Louis E. Grivetti and Howard-Yana Shapiro (Hoboken, NJ, 2009), 923.

17. As quoted in Jones 2015.

18. Colin Jones, *Madame de Pompadour: Images of a Mistress* (London and New Haven, 2003), 60–61.

19. For further discussion of chocolate's restorative and erotic associations, see Mimi Hellman, "Of Water and Chocolate," *Gastronomica: The Journal of Critical Food Studies* 4 (fall 2004): 9–11.

20. Beatrice Hohenegger, *Liquid Jade: The Story of Tea from East to West* (London and New York, 2007), 67; see also Ellis, Coulton, and Mauger 2015, 22–23.

21. See Brian Goodman, "The Dutch East India Company and the Tea Trade," *Emory Endeavors in World History* 3 (2010): 60–68.

22. C.G. Brouwer, "Al-Mukhā as a Coffee Port in the Early Decades of the Seventeenth Century According to Dutch Sources," in *Le Commerce du Café avant l'ère des plantations coloniales: Espaces, réseaux, sociétés (XVe–XIXe siècle)*, edited by Michel Tuschscherer, Cahier des Annales isla mologiques 20 (2001): 271–95.

23. Jones 2003, 51.

24. Haydn Williams, *Turquerie: An Eighteenth-Century European Fantasy* (New York, 2014), 7.

25. For further discussion of coffee's role in fueling orientalism in France, see chapter 6 ("Coffee and Orientalism in France") of Ina Baghdiantz McCabe, *Orientalism in Early Modern France: Eurasian Trade, Exoticism, and the Ancien Régime* (Oxford and New York, 2008); see also Susan Landweber, "'This Marvelous Bean': Adopting Coffee into Old Regime French Culture and Diet," *French Historical Studies* (2015): 193–203.

26. Jim Chevallier, "The Queen's Coffee and Casanova's Chocolate: The Early Modern Breakfast in France," in *Consuming Culture in the Long Nineteenth Century: Narratives of Consumption, 1700–1900*, edited by Tamara S. Wagner and Narin Hassan (Lanham, MD, 2007). Chocolate was also a mainstay of Colonial America's breakfast table. See, for example, Nicholas Westbrook, Christopher D. Fox, and Anne McCarty, "Breakfasting on Chocolate: Chocolate in Military Life on the Northern Frontier, 1750–1780," in Grivetti and Shapiro 2009, 399–412.

27. For the phenomenon of coffeehouses in England, see Brian Cowan, *The Social Life of Coffee: The Emergence of the British Coffeehouse* (London and New Haven, 2005).

28. Hellman 2004, 9.

29. For further discussion, see Woodruff Smith, *Consumption and the Making of Respectability, 1600–1800* (London, 2002).

30. For further discussion of British conversation pieces, see Ching-Jung Chen, "Tea Parties in Early Georgian Conversation Pieces," in *The British Art Journal* 10 (spring/summer 2009), 30–39. See also the brief discussion of the representation of chocolate in French portraiture in Suzanne Perkins, "Is It a Chocolate Pot? Chocolate and Its Accoutrements in France from Cookbook to Collectible," in Grivetti and Shapiro 2009, 157–76, esp. 167–69.

31. See chapter 4 ("The Elevation of Tea") in Ellis, Coulton, and Mauger 2015, 73ff.

32. See Anne Dulau, *Boucher and Chardin: Masters of Modern Manners* (London and Glasgow, 2008), in particular Dulau's essay "In Focus: *Lady taking Tea* and *Woman on a Daybed*," 8–25.

33. For more about coffeehouses in Germany, see chapter 9 ("The New Stimulants and Sociability") in Michael North, *Material Delight and the Joy of Living: Cultural Consumption in the Age of Enlightenment in Germany*, translated by Pamela Selwyn (Aldershot, UK, and Burlington, VT, 2008), 153–68. See also Ulla Heise, *Coffee and Coffee Houses* (Atglen, PA, 1987).

34. Peter Albrecht, "Coffee-Drinking as a Symbol of Social Change in Continental Europe in the Seventeenth and Eighteenth

Centuries," *Studies in Eighteenth-Century Culture* 18 (1988): 91–103; cf. Robert Liberles, "Jews, Women, and Coffee in Early Modern Germany," in *Gender and Jewish History*, edited by Marion A. Kaplan and Deborah Dash Moore (Indianapolis, 2011), 44–58, esp. 47.

35. For general discussion, see Ann Eatwell, "Tea à la Mode: The Fashion for Tea and the Tea Equipage in London and Paris," in Dulau 2008, 50–77. For the trembleuse, see Christine Jones, "Caution, Contents May Be Hot: A Cultural Anatomy of the *Tasse Trembleuse*," in *Eighteenth-Century Thing Theory in a Global Context: From Consumerism to Celebrity Culture*, edited by Christina Ionescu and Ileana Baird (Farnham, UK, 2013), 31–48.

36. Ross W. Jamieson, "The Essence of Commodification: Caffeine Dependencies in the Early Modern World," *Journal of Social History* 35 (winter 2001): 269–94.

37. S. D. Smith, "Accounting for Taste: British Coffee Consumption in Historical Perspective," *The Journal of Interdisciplinary History* 27 (autumn 1996): 183–214.

38. Goodman 1995, 129.

39. Sidney Mintz, *Sweetness and Power: The Place of Sugar in Modern History* (New York, 1985).

40. See chapter 2 ("Milk: 'No finer investment'?") in John Burnett, *Liquid Pleasures: A Social History of Drinks in Modern Britain* (London and New York, 1999), 29ff.

41. Ivan Day, "Sculpture for the Eighteenth-Century Garden Dessert," in *Food in the Arts: Proceedings of the Oxford Symposium on Food and Cookery* (Oxford, 1998), edited by Harlan Walker, 57–66; Ivan Day, *Royal Sugar Sculpture: 600 Years of Splendour* (Teesdale, UK, 2002).

42. "Caffeine (Coffee) Consumption By Country," http://www.caffeineinformer.com/caffeine-what-the-world-drinks [accessed April 26, 2016].

43. Ellis, Coulton, and Mauger 2015, 267.

44. Niall McCarthy, "The World's Biggest Chocolate Consumers," July 24, 2015, https://www.statista.com/chart/3668/the-worlds-biggest-chocolate-consumers/ [accessed April 27, 2016].

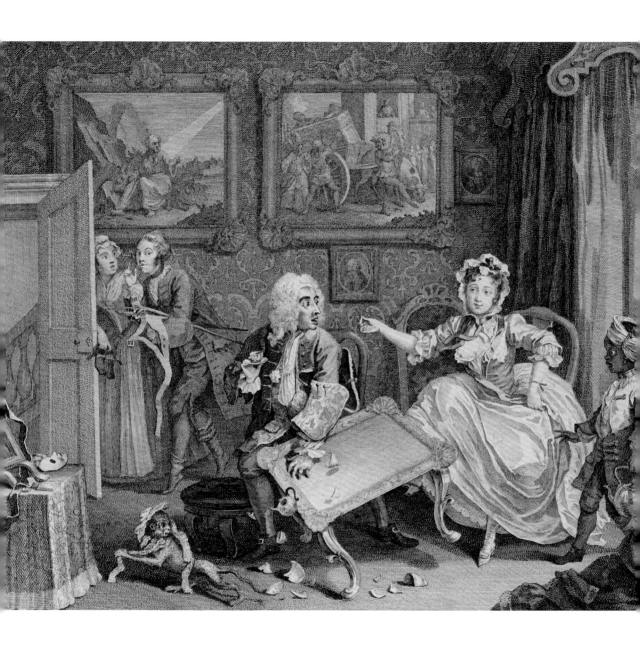

HOPE SASKA

Tipping Tea Tables and Coffeehouse Mobs: Coffee and Tea in Graphic Satire

Aᴍᴏɴɢ ᴛʜᴇ ꜰᴀꜱʜɪᴏɴꜱ and tastes of the day, the growing consumption of tea and coffee provided rich material for ridicule by graphic satirists and caricaturists working in eighteenth-century London. Numerous print satires took on the culture of coffee and tea, thus offering another lens through which the visual and material culture of polite consumption may be viewed.

Just as coffee, tea, and chocolate were somewhat recent additions to the European diet, the social settings in which these beverages were enjoyed—and the social practices with which they were associated—were likewise new. In his 1725 manual for the English tradesman, Daniel Defoe (1660–1731) expressed unease about the social impact of the coffeehouse and the tea table:

> The tea-table among the ladies and the coffee-house among the men seem
> to be places of new invention for a deprivation of our manners and morals;
> places devoted to scandal, and where the characters of all kinds of persons
> and professions are handled in the most merciless manner; where reproach
> triumphs, and we seem to give our selves a loose to fall upon one another
> in the most unchristian and unfriendly manner in the world.[1]

Defoe's descriptions of the lady's tea table and the gentleman's coffeehouse provide insight into the ambivalence with which Londoners living in the eighteenth century approached these social spaces, particularly the coffeehouse. His commentary resonates with contemporary concerns about behaviors that *could* develop, namely gossip and reproach, instead of behaviors that productively cemented familial bonds or enhanced the reputation and, therefore, the credit of a gentleman.

Fig. 1. William Hogarth, *A Harlot's Progress*, 1732, etching with engraving. The Lewis Walpole Library, Yale University

Among the commentators who echoed Defoe's sentiments, graphic satirists and caricaturists critiqued the social sites of coffeehouse and tea table with images that are both poignant and entertaining. Adept observers, satirists presented multifaceted commentary on the types of behaviors that alarmed Defoe and others. In their humorous depictions of social interactions around the tea table or in the coffeehouse, graphic satirists conveyed the noise and bustle of social exchange, bringing to life the social practices—both real and imagined—that accompanied the drinking of coffee, tea, and chocolate.

TIPPING THE TEA TABLE

Painter and engraver William Hogarth (1697–1764) presented his first "modern moral subject" in the 1732 print series *A Harlot's Progress*. In this series, Hogarth tracks the misfortunes of Moll Hackabout, a naïve young woman whose move from the countryside to London proves disastrous. Over the course of six images, Hogarth charts Moll's progress, signaling her changes in fortune through the geography of London. The series begins with her arrival at a stagecoach depot and proceeds to her installation in an elegant apartment, where she is kept by a Jewish merchant. In the third print, she is depicted in a Drury Lane hovel and then on to Bridewell prison, a decline that results in devastating illness and, finally, death.

The success of this sad story was a boon for Hogarth, in that it opened new avenues for his professional output. Already celebrated for insightful portraits and conversation pieces featuring aristocrats and wealthy merchants, Hogarth gained name recognition among new patrons in the middle and upper classes with this series.

The "modern moral subjects" Hogarth explored in his comedic print productions capitalized on his familiarity with the tastes and habits of polite society. In the second plate of *A Harlot's Progress*, for example, Hogarth travesties the conventions of the conversation piece, providing incisive commentary on the consumption of luxury goods (fig. 1). The composition of the second plate centers on an elegant mahogany tea table, which has been overturned by Moll, seated at the right of the composition. To hide the presence of her aristocratic young lover from her older, wealthy keeper, seated at left, Moll creates a diversion by kicking the tea table and exposing her breast. The dainty tea service—notice how small the cup looks in the man's fumbling hands—crashes to the floor and shatters into pieces. Fleeing through the parlor door is Moll's young

lover, aided in his escape by a female servant who hands the young man his shoes and stealthily holds open the door. A second servant, a young black child bedecked in a turban and wearing a silver collar indicating his status as that of a slave, enters the room and is startled by the commotion. Amid this scene of coming and going, chaos erupts; mouths gape, china clatters, fingers snap, and in an instant the semblance of domesticity shared by Moll and her keeper collapses. A mask near the dressing-table mirror underscores the theatrical nature of the scene and points to the artifice and vanity displayed by Moll and revealed by Hogarth. The pet monkey, who absconds with a frill of lace, imitates his mistress's fashionably covered head, suggesting that Moll is "aping" the habits and conventions of a comfortable, middle-class lifestyle.

Compare this scene from *A Harlot's Progress* with that of domestic harmony portrayed by Charles Philips (1703 – 47) in *The Strong Family*, a painting also created in 1732 (cat. 21). Doubling as a family portrait, this conversation piece depicts the cozy conviviality of drinking tea and playing cards in familiar company. The family patriarch, Edward Strong, stands in the center of the room, and at his right Mrs. Strong presides over a tea table on which a delicate porcelain tea service is neatly displayed. The Strongs are surrounded by their children and grandchildren; the woman seated in front of Mr. Strong is very likely his daughter Susan, by marriage Lady Strange.[2] The tea table is an elegant and gleaming piece of furniture, forming the site of a lesson as Mrs. Strong instructs her grandchildren, male and female, in the proper service of tea. Together the tea table and card table anchor the composition, creating the nexus around which the multigenerational family gathers. This display of the family members surrounded by their elegant possessions demonstrates the Strong family's refinement and locates them among the polite class of well-to-do Londoners.[3]

Whereas the members of the Strong family exemplify proper comportment in their composed expressions and restrained gestures, Moll and her company behave in comically exaggerated fashion with gestures that are abrupt or overextended. What is more, the figures in *A Harlot's Progress* are noisy; they gasp and exclaim and break porcelain. The Strongs, on the other hand, are hushed; gentle smiles play on the lips of the figures, but no one appears to be speaking in this conversation piece. Furthermore, the restrained and severely ordered décor of the Strong family's sitting room contrasts with the excessively ornamented interior of the harlot's apartment.

Moll's overturned tea table demonstrates a reversal of familial—and, therefore, social—order, while also pointing to the instability of colonial exchange and the commodification of individuals. The porcelain tea service, the tea and sugar it holds, and the mahogany used to construct the table are examples of the many commodities introduced to London through British colonialism and trade. The pet monkey and the black child are similarly displayed as colonial goods, and signal a taste for exoticism and luxury prevalent in the British capital.[4] Comparisons may be made between the vignette described by Hogarth and other ceramic groupings that feature black servants serving hot beverages (see cats. 8, 14, and 61).

The relationship between the tea table and empire is a theme frequently explored by print satires featuring the consumption of tea. One of the most trenchant is James Gillray's (1756/57–1815) masterful satiric caricature of the British royal family, *The Anti-Saccharrites, or John Bull and His Family Leaving Off the Use of Sugar* (fig. 2). In this large and beautifully hand-colored etching, George III and Queen Charlotte gather with the six royal princesses around a small table (in all, George III and Charlotte had fifteen children). The king and queen dominate the table and are shown *en famille*: Charlotte wears a simple cap with undressed hair and the six princesses seated at the edge of the table are similarly attired without ribbon or jewel in sight. George III is at ease in rumpled clothing and unpowdered wig, and enthusiastically slurps his tea muttering "O delicious! delicious!"; the princesses approach their cups with dubious and mournful expressions. Notably, the sugar bowl is missing from the family tea service.

The incomplete tea service and the dour expressions of the princesses indicate the impact of the anti-saccharite movement, wherein the consumption of colonial sugar was boycotted. Queen Charlotte explains: "O my dear Creatures, do but Taste it! You can't think how nice it is without Sugar:—and then consider how much Work you'll save the poor Blackeemoors by leaving off the use of it!—and above all, remember how much expence it will save your poor Papa!—O its charming cooling Drink!" In this satire as well as throughout his oeuvre, Gillray depicts the royal couple as reveling in their miserly habits. Here the horrors of the slave trade are a secondary motivation to the desire to pinch a pound. Moreover, so divorced is Charlotte from the actualities of colonial consumption that her statement poses that the lives of slaves on plantation as little more than a bit of bother.

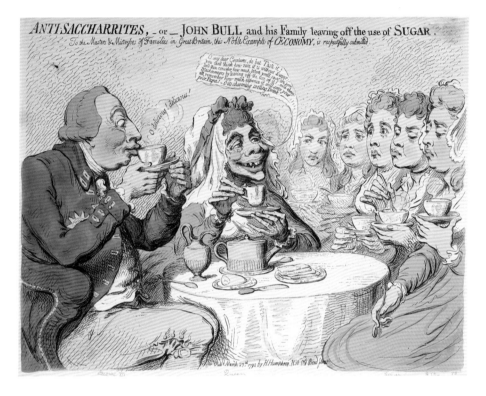

Fig. 2. James Gillray, *The Anti-Saccharrites, or John Bull and His Family Leaving Off the Use of Sugar*, 1792, etching. The Lewis Walpole Library, Yale University

Gillray's representation of the royal tea table, with its cramped surface and simple white tablecloth, is more fitting of a middle-class family than it is of pampered royals. This echoes Gillray's suggestion of royal parsimony and perhaps also suggests the adoption of tea by a far wider swath of the population. For many Britons, enjoyment of a cup of tea, coffee, or chocolate was dependent on the availability of sweetener. And, as Gillray's print indicates, the addition of refined sugar to the European tea table was an essential part of the ritual, so much so that a boycott of sugar was tantamount to a boycott of tea. Colonial groceries were intertwined to the extent that leaving off one product directly affected the consumption of another. Sugar consumption grew by leaps and bounds in the eighteenth century: between 1690 and 1790, the consumption of imported sugar rose from four to twenty-four pounds per head;

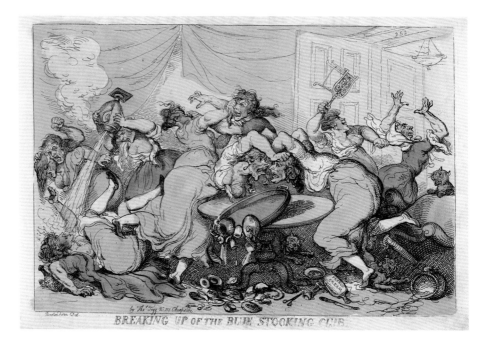

Fig. 3. Thomas Rowlandson, *Breaking Up of the Blue Stocking Club*, 1815, etching. The Lewis Walpole Library, Yale University

between 1730 and 1790, the per capita consumption of tea rose from one-half to more than two pounds annually.[5] While these statistics demonstrate an increasing market for the products across social classes, they also show that imported sugar was eclipsing the use of traditional sweeteners such as honey.[6] As Joanna de Groot has noted, the "presence of colonial production in metropolitan life was both pervasive (the role of sugar, tea, or tobacco in mass consumption) and invisible (the unseen commercial and exploitative structures of colonial power or labor which delivered the products)."[7] In Gillray's satire, the ridiculousness of the royal family's inability to enjoy tea without sugar is compounded by their inability to comprehend the effect of British economic policies.

The stimulating effects of caffeinated beverages were common tropes of British satire, wherein overindulgence in caffeine resulted in heated and irrational arguments, and sometimes even in blows. The effects of caffeine are

often exploited for comic effect in satires of coffeehouses, however women were also shown as being driven to extreme behavior by tea. In the satirical view, women left alone at their tea tables, without the oversight of male companions or the occupation of childcare, were transformed into harridans, consumed by rumor and gossip. In Thomas Rowlandson's (1765–1827) *Breaking Up of the Blue Stocking Club* (fig. 3), a brawl breaks out in a drawing room. Women tear at each other, clawing through clothing and dismantling coiffures in the heat of a desperate argument. The cause of the dispute is of no importance: it is enough to know that the women are Blue Stockings, members of a learned social group that convened to discuss topics ranging from literature to politics and public events. Akin to the Salons organized by French aristocracy, Blue Stocking gatherings were inclusive, bringing together men and women of mixed classes for conversation. When Rowlandson made this image, the term Blue Stocking was separated from its original meaning and used to describe women whose intellectual interests expanded beyond those deemed suitable for female occupation. At a time when female education was based in the home, and was primarily concerned with imparting domestic skills and social accomplishments, Blue Stockings took it upon themselves to engage with the world beyond the domestic sphere. Thus, Rowlandson's satire conflates tipping over the tea table with a rejection of traditional female social interaction.

Not only are the women taking on physical attributes associated with men — their bellicosity implied by bulging muscles — their debate of philosophy and politics has also made them masculine, with habits better suited to the coffeehouse. Rowlandson signals an additional source for this brawl: a beaker of "French Cream" spilled under the table. In his *Dictionary in the Vulgar Tongue*, Francis Grose identifies "French cream" as "Brandy, so called by the old tabbies and dowagers when drank in their tea."[8] Yet a double entendre cannot have been lost on Rowlandson, since the concerns of the Blue Stockings were also associated with revolutionary political ideals imported from France.

COFFEEHOUSE MOBS

Since their arrival on the cultural map in the last decades of the seventeenth century, coffeehouses were associated with the world of men, both as sites for political debate and as locations where business transactions were arranged. Promoted as more salubrious than taverns, coffeehouses advertised the stimulating effects of the beverage, credited with encouraging conversation. As

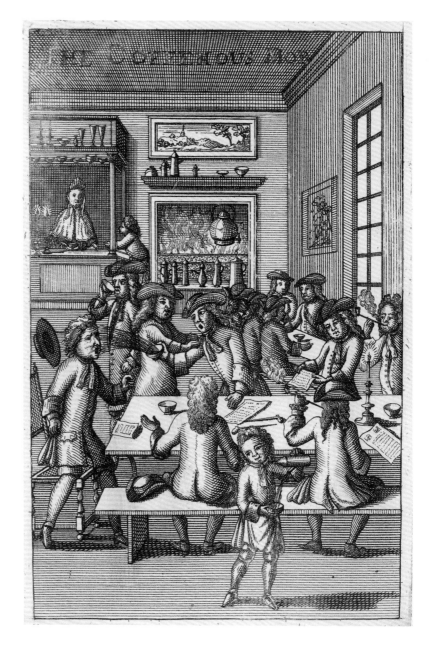

Fig. 4. Frontispiece to the *The Fourth Part of Vulgus Britannicus; or the British Hudibras* (London, 1710), *The Coffeehous Mob*, engraving. © The Trustees of the British Museum

noted by Defoe in the opening quote, the coffeehouse was an environment in which a man's public reputation could be established, for better or worse. Often described as "penny universities," coffeehouses were open to anyone who could afford the modest admission fee. For the price of a penny, the coffeehouse patron was poured a hot beverage and enjoyed access to the newspapers, broadsides, and pamphlets provided by the proprietor.

Among the publications available in London coffeehouses, the *Tatler*, the *Spectator*, and the *Guardian* were familiar features. Produced by Richard Steele and Joseph Addison (cat. 22), these periodicals presented the coffeehouse as a site of ideal masculine comportment. In particular, the *Spectator* imaged a character called "Mr. Spectator," who made rounds of the city's coffeehouses describing the people he encountered and the conversations overheard.[9] By idealizing coffeehouse society for their readers, Addison and Steele hoped to reform social behavior both inside and outside the coffeehouse. As Addison and Steele worried, and as Defoe had occasion to complain, coffeehouse conversation was not always so high-minded, and sometimes a display of wit could devolve into lower forms of humor.[10]

So associated were coffeehouses with wit and humor that joke books, such as a slim volume entitled *Coffee House Jests*, were targeted at the coffeehouse patron. Promising merry companionship and replete with "witty jests, wise sayings, smart repartees, Jokes, Pleasant Tales and Buils [*sic*],"[11] jest books were used in a variety of ways. Read aloud or silently, they promised to make the dullest individual interesting. The circulation of jest books for entertainment in the coffeehouse further points to the intimate connection between the coffeehouse and print culture. Just as coffeehouses were sites wherein ideas circulated and percolated, they were also rich in printed material supplied by the coffeehouse and patrons.[12]

Caffeine and political conversation combine to disastrous effect in *The Coffeehous Mob* (fig. 4), initially published as a satirical frontispiece to the *Fourth Part of Vulgas Britannicus; or the British Hudibras*. The simply rendered image shows the interior of a London coffeehouse with a large fireplace at the back of the room for brewing coffee, and a bar laden with glassware for the serving of drinks. The melee depicted in this satire is associated with the Sachervell affair, particularly the riots that occurred after the arrest of Henry Sachervell, an Anglican preacher who delivered a sermon indicting Whig politicians. The event was featured in a range of publications, and later reprints of images like the *Coffeehous Mob* were redirected toward any topical political dispute. Fueled

by broadsides and newspapers, the patrons in the *Coffeehous Mob* have left behind their civil debate of the affair and are attacking each other by throwing coffee as a retort. Notably, the barmaid is the sole female present in the coffeehouse; although she presides over the brewing of coffee, and over the cups and implements that surround her, she is separated from the coffeehouse floor by the bar. Brian Cowan has explored the extent to which women participated in coffeehouse culture, describing their presence as both servers and proprietors, and very rarely as patrons.[13] The coffeehouse was not an entirely welcoming environment for women, and servers and proprietors alike frequently received unwanted attention.

The antics depicted in *The Coffeehous Mob* (1710) are remarkably similar to those Rowlandson depicted nearly a century later in his satire of Blue Stockings taking tea. Yet there are two notable differences: first, while the coffeehouse mob may be disorderly, it does not disrupt the overall order of the coffeehouse. Second, the mob's antics are not contagious, as only a small portion of the group is in uprising. That such devolution of discussion is commonplace is indicated by the calm demeanor of the other coffeehouse patrons and by the composure of the woman who tends the bar.

Rowlandson's *A Mad Dog in a Coffee House* (1809; fig. 5) depicts a crowded coffeehouse in tumult, not because of a political disagreement but due to the arrival of a rabid dog. Hackles up and tail tucked, the dog gleefully catches the viewer's eye. A full coffeepot spills onto the lap of a man who has taken refuge under the table while two brave souls attempt to encourage the dog to move onward by prodding it with an umbrella and fireplace tongs. Other patrons climb atop tables or run from the room. The male patrons are mostly city folk, merchants from the middle class, judging from their clothing and by the bills posted to the wall, one indicating the "price of stoks [sic]" and the other advertising a vessel called "The Cerberus" (commentary on the rabid mutt). Before the arrival of the dog, it is likely these men were drawn together in conversation, or as in the case of the man seated at the lower right of the composition, solitarily reading and writing.

Thus it is the dog, rather than political dispute, that provides the source of chaos. Indeed, by the late eighteenth and early nineteenth centuries, the disposition of coffeehouses had changed with the arrival of private clubs, where aristocratic patrons tended to gravitate. Coffeehouses continued to provide an important venue for social exchange in the city and became highly specialized,

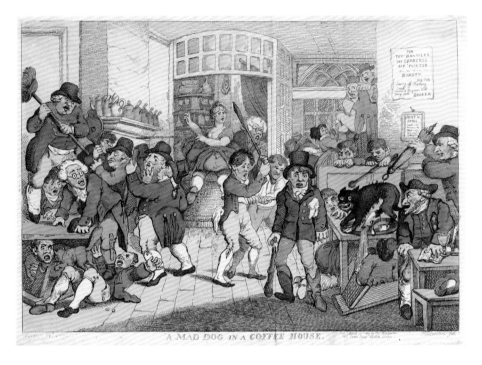

Fig. 5. Thomas Rowlandson, *A Mad Dog in a Coffee House*, 1809, etching.
The Lewis Walpole Library, Yale University

catering to specific clientele. Their place as "penny universities" had shifted.
Yet, despite the social changes of the coffeehouse, the interior of the establish-
ments remained remarkably similar over the century. In the *Coffeehous Mob*
and in *Mad Dog*, the coffeehouse remains a large, open room furnished with
long tables and benches. A fireplace provides warmth and a place for brewing
coffee. The mantel is decked with an array of handled pots that bear the long
spout characteristic of coffeepots; the other pots on the mantel could be used
for chocolate or tea. In both images, the female server presides over a bar at
the back of the room, standing in a small alcove separated from the main room
with shelving laden with stemmed glasses and deep bowls. Rowlandson's serv-
ing woman is characteristically buxom and statuesque, suggesting one of the
attractions of the venue, especially in contrast to the comically awkward and
ungainly men in the coffeehouse.

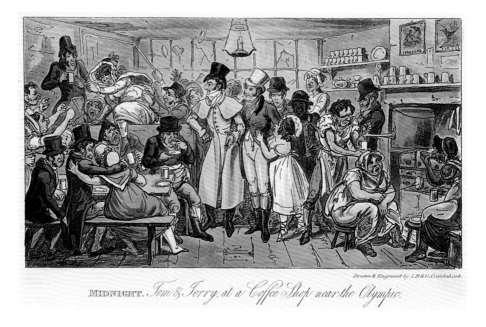

Drawn & Engraved by I.R.& G.Cruikshank.

MIDNIGHT. *Tom & Jerry, at a Coffee Shop near the Olympic.*

Fig. 6. George and Isaac Robert Cruikshank, *Midnight. Tom and Jerry at a Coffee Shop near the Olympic*, 1820, aquatint and etching. The Lewis Walpole Library, Yale University

The noisome and noisy interior of a coffeehouse near the Olympic Theater on Wych Street in London is a late-night destination for Tom and Jerry on their jaunt through the city (fig. 6). Etched by brothers George and Isaac Robert Cruikshank, the colored aquatint was an illustration in Pierce Egan's serial publication *Life in London*, an account of the titular characters' "Rambles and Sprees through the Metropolis."[14] Young men about town, Tom and Jerry romped through a variety of London locales associated with entertainment and pleasure. In their search to explore London both high and low, Tom and Jerry cap their night at a coffeehouse frequented by prostitutes, low-life roughs, and lower-class men and women. Egan neatly characterizes the scene as one of "drunkenness, beggary, lewdness and carelessness," and for his middle-class reader he describes the setting as offering a new and different view of the city.[15]

The adventuring characters Tom and Jerry are tall and elegantly dressed, head and shoulders above the squat and comically grotesque men and women

in the coffee shop. With slightly bemused expressions, they appraise the surrounding squalor; it seems unlikely that Tom and Jerry plan to order a cup of coffee. Instead, their voyeuristic foray into a lower-class environment is, as Jane Rendell describes, carefully constructed to allow the viewer to "experience an urban realm in a form that everyday life, with its class barriers created by elitism and fear, did not allow."[16] The coffeehouse is to be explored by urban anthropologists who take in low-life characters: among them, bawds on their last legs; fallen Venuses; and a proprietor who rolls up his sleeves to pour coffee from a tank hanging over a roaring fire, a travesty of Vulcan at his forge. Yet, despite the depiction of the coffeehouse as ramshackle and slightly dangerous, the comic image suggests that this venue, located in the disreputable Strand, is also a place of warmth and welcome for the urban poor.

As counterparts to polite visual culture, the satires and caricatures depicting the coffeehouses and tea tables of eighteenth-century London provide an alternate view into these social spaces. Just as tea and coffee were consumed in elegant drawing rooms, so, too, were graphic satires, either purchased as individual sheets or, toward the end of the eighteenth century, rented in albums composed for an evening's entertainment.[17] Certainly some readers of Egan's *Life in London* read about Tom and Jerry with a steaming cup of tea at their elbow. When considered alongside the delicate porcelain teacups and the gleaming silver coffeepots, visual satire provides a fuller picture of how men and women of the Enlightenment consumed culture.

1. Daniel Defoe, *The Complete English Tradesman, in Familiar Letters; Directing Him in All the Several Parts and Progressions of Trade* (London, [1726]). Eighteenth Century Collections Online. Gale. University of Colorado Boulder [accessed November 14, 2015]. http://0-find.galegroup.com.libraries.colorado.edu/ecco/infomark.do?&source=gale&prodId=ECCO&userGroupName=coloboulder&tabID=T001&docId=CW3307375202&type=multipage&contentSet=ECCOArticles&version=1.0&docLevel=FASCIMILE.

2. Katherine Baetjer, *British Paintings in the Metropolitan Museum of Art, 1575–1875* (New York, 2009), 52–53, cat. no. 23.

3. Kate Retford, "From the Interior to Interiority: The Conversation Piece in Georgian England," *Journal of Design History*, 20, no. 4 (winter 2007): 294.

4. David Dabydeen has discussed at length the rampant symbolism of slavery and colonial profits in *A Harlot's Progress*, describing the series as "Hogarth's most poignant and bitter representation of the squalid and dehumanizing commercialism characteristic of the times." *Hogarth's Blacks: Images of Blacks in Eighteenth Century English Art* (Manchester, 1987), 101–32, esp. 101 and 113. See also David Bindman, "'A Voluptuous Alliance between Africa and Europe': Hogarth's Africans," in *The Other Hogarth: Aesthetics of Difference*, edited by Bernadette Fort and Angela Rosenthal (Princeton, 2001), 260–69.

5. Joanna De Groot, "Metropolitan Desires and Colonial Connections: Reflections on Consumption and Empire," in *At Home with the Empire: Metropolitan Culture and the Imperial World*, edited by Catherine Hall and Sonya O. Rose (Cambridge, 2006), 171.

6. Anna McCants, "Poor Consumers as Global Consumers: The Diffusion of Tea and Coffee Drinking in the Eighteenth Century," *The Economic History Review*, n. s. 61, no. 51, *Feeding the Masses: Plenty, Want and the Distribution of Food and Drink in Historical Perspective* (August 2008): 175. See also De Groot 2006, 171.

7. De Groot 2006, 170.

8. Francis Grose, *1811 Dictionary of the Vulgar Tongue: A Dictionary of Buckish Slang, University Wit, and Pickpocket Eloquence.* http://www.gutenberg.org/cache/epub/5402/pg5402-images.html [accessed February 25, 2016].

9. Markman Ellis, *The Coffee House: A Cultural History* (London, 2004), esp. 185–203.

10. As historian Brian Cowan notes, the presentation was made "in opposition to much more widespread fears that coffeehouse society was decidedly uncivil and impolite." Brian Cowan, *The Social Life of Coffee: The Emergence of the British Coffeehouse* (New Haven, 2005), 229.

11. William Hickes, *Coffee-House Jests. Being a merry companion: containing witty jests, wise sayings, smart repartees, Jokes, Pleasant Tales, Notable Buils. with several short delightful histories, novels, and other curious fancies* (London, [1733]). Eighteenth Century Collections Online. Gale. University of

Colorado Boulder [accessed November 14, 2015]. http://0-find.galegroup.com.libraries .colorado.edu/ecco/infomark.do?&source= gale&prodId=ECCO&userGroupName= coloboulder&tabID=T001&docId=CW 3316219495&type=multipage&contentSet= ECCOArticles&version=1.0&docLevel= FASCIMILE.

12. See Ellis 2004, 150–51 and 172–74. For coffeehouse auctions of prints, see Mark Hallett, *The Spectacle of Difference: Graphic Satire in the Age of Hogarth* (New Haven, 1999),16. See also Cowan 2005, 132–45.

13. Brian Cowan, "What was Masculine about the Public Sphere? Gender and Coffeehouse Milieu in Post-Restoration England," *History Workshop Journal* 51 (spring 2001): 127–57.

14. Pierce Egan, *Life in London; or the Day and Night Scenes of Jerry Hawthorn, Esq., and His Elegant Friend Corinthian Tom, Accompanied by Bob Logic, the Oxonian in Their Rambles and Sprees in the Metropolis* (London, 1820–21).

15. Pierce Egan, *Life in London; or the Day and Night Scenes of Jerry Hawthorn, Esq., and His Elegant Friend Corinthian Tom, Accompanied by Bob Logic, the Oxonian in Their Rambles and Sprees in the Metropolis,* later edition (London, 1869), 219.

16. Jane Rendell, *The Pursuit of Pleasure: Gender, Space, and Architecture in Regency London* (New Brunswick, NJ, 2002), 36; see esp. 33–38.

17. Diana Donald, *The Age of Caricature: Satirical Prints in the Reign of George III* (New Haven, 1996). For a discussion of the circulation and display of graphic caricature and satire, see 1–21.

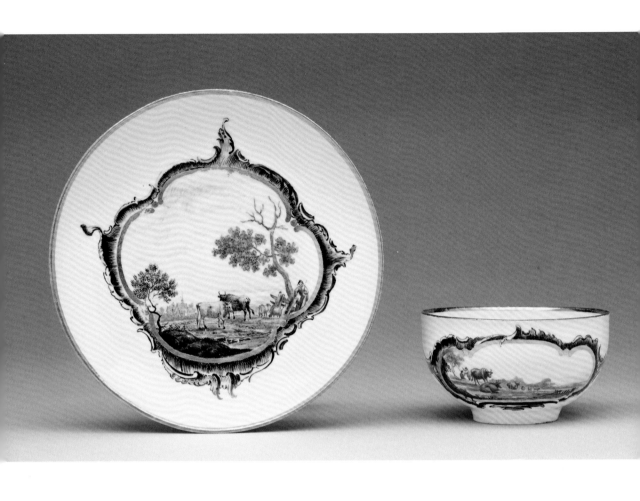

YAO-FEN YOU

The Detroit Fürstenberg Service and the Politics of Coffee and Tea in Eighteenth-Century Germany

ALTHOUGH COFFEE, TEA, AND CHOCOLATE wares in different sizes and shapes were among the earliest products of European porcelain manufactories, coordinated hot beverage services with matching cups and saucers, serving pots, and other service items—all with the same decoration—were not introduced as stock items until the 1750s, well after the taste for the new hot drinks had been firmly established in Europe. Matched beverage sets extended the principle of serial design underpinning the highly fashionable eighteenth-century French interior, complementing and playing off the matching furniture sets, multipiece mantelpiece ornaments (*garnitures*), and sets of decorative paintings.[1] As such, they were highly visible markers of affluence and taste.

The Fürstenberg Porcelain Manufactory, established at Braunschweig in 1747, had services available for purchase by early 1751, and *déjeuners* (small tea services with matching trays) were in production at the Sèvres Porcelain Manufactory by 1753. Though earlier examples of matching beverage services made by the Meissen Porcelain Manufactory are known from the period around 1725, almost all were commissioned as diplomatic state gifts, such as the splendid set given by August III of Poland and Saxony to Queen Ulrika Eleonora and King Fredrik I of Sweden (Nationalmuseum, Stockholm, NMK 158 / 1897).[2] Otherwise, sets were assembled from disparate but related items and unified by custom-made cases, such as the Boston tea service (1728−29) that combines a silver teapot and silver tea caddy—both of Parisian manufacture—with a silver-mounted Japanese (Arita) porcelain sugar bowl and Japanese (Kakiemon) enameled porcelain tea bowl and saucer (cat. 68). The Breakfast Service from the Clark Art Institute, composed of pieces of German gilt silver and Meissen porcelain, is another magnificent example of an assembled set (cat. 20).

Fig. 1. *Coffee Cup and Saucer*

Cat. 68. Probably by Martin Berthe, *Tea Service with Fitted Case*, 1728–29

Once established as inventory items in regular production, matching services varied widely in composition and size. As pieces could be purchased as a set or assembled according to the customer's needs, taste, and budget, any number of configurations was possible. The dizzying array of shapes and forms, at different levels of quality and expense, allowed collectors to show off their aesthetic judgment. At both Sèvres and Fürstenberg, beverage wares were often available in at least three, and as many as five, graduated sizes. The 1779 Fürstenberg price list for assorted coffee tableware (*Sorten Caffé-Geschirre*) indicates the availability of teapots (*Thé-Kanne*) in five different sizes that year, at eight different price points. Customers could choose, for example, between a "smooth surface with colorful flowers" (*glatt mit bunten oder andern couleurten Blumen*) or a "smooth surface with landscapes and gold edges" (*glatt mit bunten Landschaften und goldener Kante*), which was top of the line. There was also an option of cups "with handles" (*mit Henkel*) and "without handles" (*ohne Henkel*).[3] Such choices communicated the refinement and status of their owner.

The configuration and design of services also varied according to their place of manufacture. Not all countries took to the three beverages in the same way, although combined services might give the impression that their reception was equal throughout Europe. Cultural preferences and differences of taste are subtly encoded in the design and composition of the services. In France, coffee was by far the most successful import, followed by chocolate.[4] Hence, tea caddies were rarely included in a Sèvres *déjeuner,* even though teapots were an essential component. This configuration persisted well into the nineteenth century, as evidenced by the Detroit *Déjeuner Chinois Réticulé* (cat. 58). In view of England's preoccupation with tea, "the French described tea drinking as 'à l'anglaise.'"[5] Sèvres was also fond of matching serving trays that could accommodate the whole service, but did not produce teapot stands or spoon trays — defining elements of English services. In fact, a spoon tray that served as a receptacle for the wet teaspoons used to stir the tea (or coffee) is a direct response to the British custom of taking tea with sugar and milk. The preference for tea is often invoked to account for the absence of coffeepots in English porcelain services, even though coffee cups were provided, as is the case with the Worcester "Two Quail" thirty-two-piece set at The Henry Ford in Dearborn, Michigan (cat. 45). English porcelain coffeepots were made, but it remains unclear if they were considered essential components of a complete set.[6]

Like the French, the Germans took more to coffee than tea. By 1715 there are nineteen terms associated with coffee in the *Nutzbares, galantes und curiöses Frauenzimmer-Lexicon,* the oldest German conversational encyclopedia for women, compared to six for tea and a mere four for chocolate.[7] In fact, the extensive vocabulary associated with coffee by 1715 is but one indication of coffee's rapid rise in popularity once it started to gain traction at the end of the seventeenth century. Coffeepots are understood to be the centerpieces of every service, as evidenced in the finely executed Fürstenberg beverage service in the collection of the Detroit Institute of Arts (cat. 44), where the tall, pear-shaped covered coffeepot towers over the other pieces. The vessel is so commanding and visually appealing that it is easy to overlook the set's two squat teapots — an odd inclusion that suggests an unusual emphasis on both coffee and tea. In what follows, I analyze the ways in which the composition and sumptuous design of this remarkable porcelain service respond to culturally specific, perhaps regional, concerns about coffee and tea in Germany in the second half of the eighteenth century.

The DIA's Fürstenberg service would have been a dazzling and potent signifier of its owner's wealth. In addition to the coffee- and teapots, it includes a covered milk pot, six coffee cups and saucers, and four teacups and saucers. There are twenty-four pieces in total, not counting lids. That the service differentiates between tea and coffee cups strongly suggests it once included a tea caddy, a covered sugar bowl (or a sugar bowl with saucer), and a waste bowl—requisite components of a beverage service. There may once have been porcelain spoons to match.[8] Because the coffeepot was mistaken for a chocolate pot when it was acquired, the service has been erroneously described as a chocolate and tea set instead of a coffee and tea set.[9]

The forms constituting the service are typical of Fürstenberg around 1760. The squat, tapering teapots with spouts terminating in an animal's head are typical of the early years of Fürstenberg. The pear-shaped coffeepot with its scrolled loop handle, molded beak spout, and noticeably domed cover with a pinecone knob (*Pinienknauf*) is known as early as 1755 and remained in production until at least 1760.[10] The shape of the cups with scrollwork handles and thumb rest is known from about 1755 to 1758.[11] The landscape theme of the decoration, which was popular around the 1760s, also supports the circa 1760 dating.

Each piece carries an exquisite pastoral landscape scene carefully painted in polychrome colors and enclosed in an exuberant rocaille frame rendered in black and accented with gold. There is a strong possibility that the painter of the exquisite landscape scenes may have been the very talented Pascha Weitsch (1723–1803), who joined Fürstenberg in 1757. The saucers are fully decorated in this manner (fig. 1) and the main serving pieces—coffeepot (figs. 2a–b), teapots (figs. 3a–b, 4a–b), milk pot (figs. 5a–b)—are painted on both sides. The scenes follow the format of seventeenth-century Dutch landscape pictures, with the sky occupying the top two-thirds of the composition and the landscape the bottom third. Shepherds and farm animals (cattle, sheep, and donkeys) lounge idly in the foreground. Not a single scene is repeated. The cup interiors are decorated with various configurations of sheep and cattle that are only seen right side up when the handles are turned to the right, in the three o' clock position (fig. 6). This orientation, built into the design, assumes a right-handed user, which was customary.

The landscapes on the main serving pieces are further elaborated by cityscapes in the distant background. Those on the coffeepot might represent Braunschweig (fig. 2a) on one side and Wolffenbüttel on the other (fig. 2b).[12] If so, these would be the only topographically accurate landscapes in the service.

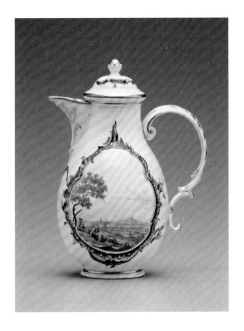

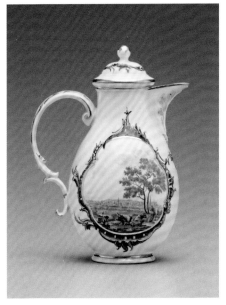

Fig. 2a. *Coffeepot* (spout facing left) Fig. 2b. *Coffeepot* (spout facing right)

This supports the attribution of the painting to Weitsch, who specialized in landscape scenes after nature. It also serves to further denote the coffeepot's special status as the centerpiece and perhaps provides clues about the service's privileged owner.

The Detroit service's two teapots of different sizes are exceptionally rare, if not unique. I have yet to come across another example, but there is no question that the pieces were meant to be part of a matching set in view of the decoration. The consistency of the decorative scheme is so overwhelming in its conception and execution that it is easy to overlook a small but significant point of inconsistency: the teapots represent two different models instead of two graduated sizes of one model. They differ primarily with regards to the respective shape of their handle. The larger pot (fig. 3a)—measuring 3¼ inches high—has the double C-scroll handle of the coffeepot and the milk pot / creamer, while the smaller pot (fig. 4a)—measuring 2½ inches high—has a thumb rest incorporated into a handle shaped more like a question mark. The lid of the smaller teapot also has an onion-dome-shaped knob instead of a pinecone.

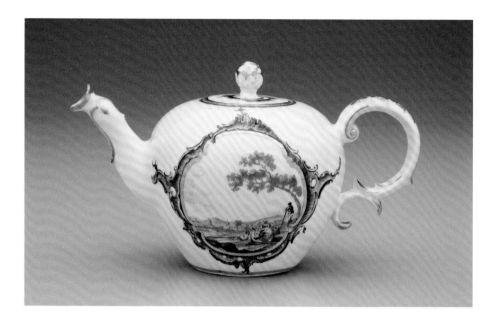

Fig. 3a. *Large Teapot* (spout facing left, above)

Fig. 3b. *Large Teapot* (spout facing right, below)

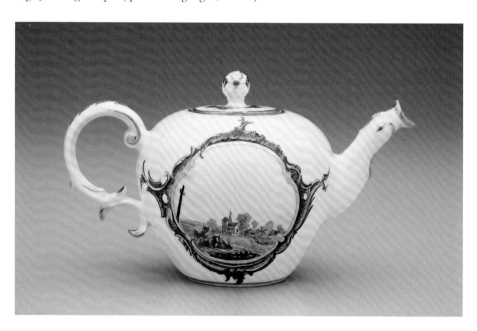

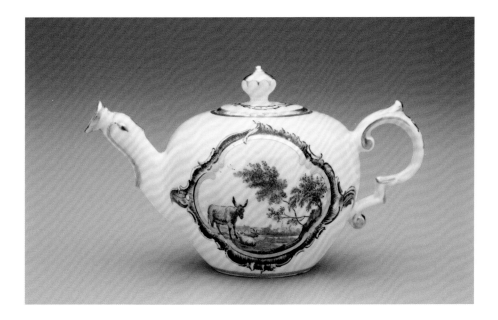

Fig. 4a. *Small Teapot* (spout facing left, above)

Fig. 4b. *Small Teapot* (spout facing right, below)

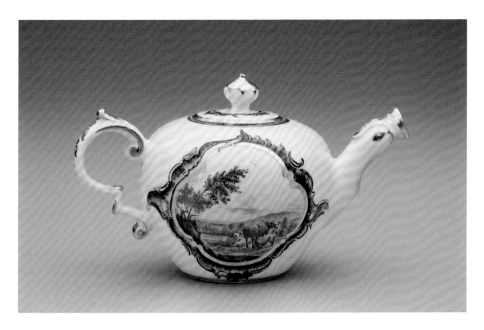

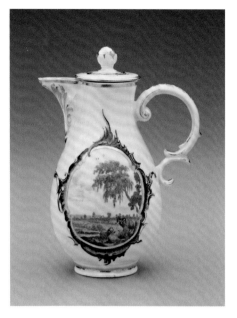 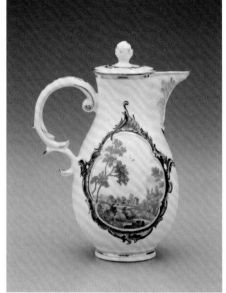

Fig. 5a. *Milk Jug* (spout facing left) Fig. 5b. *Milk Jug* (spout facing right)

Fig. 6. *Coffee Cup* (interior view)

The 1758 Fürstenberg list of sold items (*Verkaufslist*) indicates the Detroit service would have cost about forty Reichstaler, with the gilding accounting for at least a third of its overall expense. In June of that year a complete coffee and tea service comparable to the Detroit service, consisting of twelve cups and five main serving pieces (5 *große Stücke*) and decorated with purple-camaïeu landscapes and trimmed with gold, sold for forty Reichstaler.[13] If in 1700 a boat trip between Bremen and London cost four taler, then a gilt service like the Detroit one was equivalent to ten trips across the North Sea.[14] To understand the cost of the service in relation to its intended contents, it is worth noting that by 1767, a pound of coffee beans could be purchased for nineteen grote — a fraction of the cost of a richly decorated beverage service if seventy-two grote was equivalent to one Reichstaler at the time.

There are several plausible explanations for the seemingly redundant doubling of a serving pot. One concerns the preparation of tea. At the time, it was usual for tea to be diluted just before drinking, so it is entirely possible that the small pot was used for a concentrated brew of tea — the extract — and the large one for the hot water that was added to dilute it. This practice was prescribed by the famous "tea doctor" Cornelis Bontekoe in his widely read treatise on tea, *Tractat van het excellenste kruyd thee* (Treatise about the Most Excellent Herb Tea: Showing What the Right Use of it is, and its Valuable Qualities in Times of Health and Sickness), first published in 1678 and translated into German by 1692:

> Put a little [tea] in a tea-pot (either of tin, red earth or Delfs Porcelyn) which has been cleaned by rinsing it out with a little hot water, then pour water on and immediately put the lid on the pot; leave the pot a little while or put it in a bowl of hot water to draw, till the water has colour and taste; then pour a little of this extract or tincture, through the spout into a china cup, or in as many cups as there are drinkers and fill them up with water to the brim...[15]

Diderot attributed this method of brewing to the Chinese (*Les Chinois*), but it is more likely a cost-saving measure that evolved in response to the high prices that tea continued to command well into the eighteenth century. In 1736, one pound of Chinese tea cost three times as much as one pound of coffee from Martinique.[16] While this hypothesis has much to recommend it, the difference in size and volume capacity between the two vessels is not very great — about four ounces. Another hypothesis is that one pot was used for green tea and the other for black tea. This would imply a certain level of sophistication

on the part of its owner, who, perhaps, was originally from a northern German city like Hamburg, where tea was particularly appreciated.[17]

It is also possible, as Christian Lechelt has suggested, that the small pot was for meant for individual use by its aristocratic owner and the other for when she entertained her *Caffé Cräntzgen*, her daily or weekly coffee drinking group (*Kaffeekränzchen* in modern German).[18] The linguistic distinction drawn between different sized pots for different social purposes in the *Frauenzimmer-Lexicon* lends support to Lechelt's hypothesis:

> *Thee-Kanne* is a small and round piece of equipment with a handle and spout, made from brass, metal, porcelain, red stoneware, serpentine (stone) or pewter, from which tea is poured, is generally only meant to serve one or two persons, and when it is meant to serve more people, and equipped with several handles [or spigots?], it is called a *Thee-Pot*.

> [Thée-Kanne ist ein klein van Meßing, Blech, Porcellain, Terra Sigillata, Serpentin, oder Zinn rund verfertigtes Geschirr mit einer Handhabe und Schnautze, worinnen der Thee aufgegossen wird, ist insgemein nur auf eine oder 2. Personen eingerichtet, den wenn es auf mehr Personen gerichtet, und mit etliche Hänlein versehen ist, heisset es ein Thee-Pot.][19]

The small teapot would seem to fit comfortably the requirements of "Thée-Kanne," while the larger one might qualify as a "Thee-Pot." Nevertheless, it is hard to believe that the presumably elite, aristocratic owner of the Detroit set would not have had a separate service for her individual use. If one could afford a complete service from Fürstenberg, whose elegant services represented the height of eighteenth-century tableware, one would surely have been in possession of a *Thée-Dejeuner,* comprising one to two cups and saucers, a teapot, a sugar bowl, and tray.

The unusual doubling of the teapot might also reflect the status of tea as a luxury good in Germany. Tea remained significantly more expensive than coffee during most of the eighteenth century; the two only reach parity in its last decades, when the price of coffee increased with the end of the Napoleonic Wars. To have not *one*, but *two* teapots in a service would have made a strong statement about the owner's capacity to afford tea.

This kind of gross expenditure on coffee, tea, and its associated wares gave rise to vigorous political and economic debates surrounding the consumption

of the new beverages in Germany—more so coffee than tea—which reached a fevered pitch right around the time the Detroit service was made. The daily or frequent drinking of coffee was fiercely challenged in the second half of the eighteenth century by Frederick the Great (1712–86), who campaigned vociferously against the bean in the name of his subjects' health and pocketbooks. In 1766 he imposed a state monopoly on coffee imports; in 1777 he decreed that his people "must drink beer"; and in 1781 he created a royal monopoly on roasting coffee beans in an attempt to "contain the evil."[20] At the heart of Frederick's concerns was the broad use of caffeine by the middle class, which, in his mind, was contributing to the erosion of old social-class structures.[21] Coffee was a suitable drink for the aristocracy, but a ruinous luxury for commoners. His edict of 1768 rallied against "the excessive drinking of coffee and tea among common citizens, tradesmen, day labourers and servants as well as farmers, tenants, cotters, millers and the like...."[22]

While Frederick's anti-caffeine agenda ultimately sought to preserve social order, other coffee critics targeted the expenditures incurred by the coffee habit, which included not only the bean but all the equipment necessary to turn it into a warm beverage, as well as the porcelain from which to drink and serve it. In 1766, Maximilian Friedrich (1708–83), archbishop-elector of Cologne and the bishop of Münster, issued a ban on domestic possession of tea and coffee, as well as on all paraphernalia associated with their home consumption (*Thée- oder Caffée-Geschier*). The bishop of Hildesheim also called for all coffee utensils (*Caffee-Geschirre*) to be confiscated.[23]

A particularly strident critic of frequent coffee drinking was archdeacon Johann Heinrich Reß of Wolfenbüttel, though he himself presumably indulged in coffee and tea. In 1777, at an academic essay competition debating the economic and social consequences of coffee consumption, he outlined the total cost of drinking coffee from bean to social beverage:

> 1. The purchase of porcelain... Fashion demands that one have cups not just for one's own daily use, but also special ones for visitors... 2. The wholly novel expansion of household good to include the other coffee utensils. One now needs burners, mills, pots and various small items that our forefathers did not require... 3. The installation of reception rooms, which in most houses undoubtedly owe their origins to coffee, since all old people know that at the beginning of the century they existed in very few houses, because one did not need them until it became the done thing

for the lady of the house, at least, to receive visitors for coffee...4. Finally expenses for coffee and its actual accouterments...In most places, the livelihood of brewers fell to the degree that the use of coffee increased....[24]

The archdeacon's concerns are ostensibly rooted in the frivolous expenses associated with the new and fashionable social rituals surrounding these beverages—particularly parlors (*Besuchzimmern*, also called *Frauenzimmern*) and the need to furnish them—but, as Peter Albrecht has noted, they indicate significant anxiety about the changing role of women.[25]

It is worth emphasizing that the Detroit service was made in the duchy of Braunschweig-Wolfenbüttel and presumably for an aristocratic owner in the region, so for someone in the same social ambit as Reß. As such, the service— with its emphatically reiterative and top-of-the-line decorative scheme, a coffeepot and two teapots, and two kinds of cups and saucers—represents exactly the excessive and conspicuous material consumption at the heart of the archdeacon's objection. But our owner would not have been alone in possessing such a sumptuous service. A certain density of porcelain and associated beverage wares may be observed in the estate inventories of members of our owner's peer group in Braunschweig. We know, for example, that the Wolfenbüttel high court official Carl Heinrich von Bötticher owned a wide range of paraphernalia made from diverse materials, including "in silver—one coffeepot (*Kanne*), one milk jug, one little teapot, one sugar box, one tea caddy, one sugar caddy, 11 teaspoons...in pewter— 1 chocolate pot, 1 small teapot... in porcelain— 5½ pair of cups in blue and white with real gold... 1 teapot of terra sigillata, 1 paper bag filled with coffee beans." The Wolfenbüttel aulic councilor owned, among other exquisite things, a thirty-piece "coffee and tea service of Dresden porcelain" and "five blue East Indian tea bowls."[26]

These inventories also function to remind us that since the late seventeenth century porcelain had been collected throughout Europe for more than its functional properties. Beverage wares were fashionable as interior decoration, and when not in use services were often left on display in social spaces such as a *Frauenzimmer*. In fact, the pristine condition of Detroit's Fürstenberg service strongly suggests it may never have been used or was used only occasionally. That the painter of the exquisite landscape scenes may have been Weitsch raises the possibility that the service might have been a purely aesthetic object—a collector's item. One can only imagine the pride of place it would have occupied in its owner's porcelain collection.

NOTES

1. Mimi Hellman, "The Joy of Sets: The Uses of Seriality in the French Interior," in *Furnishing the Eighteenth Century: What Furniture Can Tell Us About the European and American Past*, edited by Dena Goodman and Kathryn Norberg (Milton Park, UK, and New York, 2007), 135.

2. For further discussion, see Maureen Cassidy-Geiger, "Princes and Porcelain on the Grand Tour of Italy," and Lars Ljungström, "Sweden, Hesse-Cassel, and Meissen," in *Fragile Diplomacy: Meissen Porcelain for European Courts ca. 1710–63*, edited by Maureen Cassidy-Geiger (New Haven and London, 2007), 209–56, 257–73.

3. Siegfried Ducret, *Fürstenberger Porzellan*, Vol. 2: *Geshirre* (Munich 1965), 9.

4. For further discussion of coffee's adoption into Old Regime French culture, see Julia Landweber, "'This Marvelous Bean': Adopting Coffee into Old Regime French Culture and Diet," *French Historical Studies* 38 (April 2015): 193–223.

5. Rosalind Savill, *The Wallace Collection Catalogue of Sèvres Porcelain* (London, 1988), 2:492.

6. See Catherine Beth Lippert, *Eighteenth-Century English Porcelain in the Collection of the Indianapolis Museum of Art* (Indianapolis, 1987), 184–86. A noticeable exception is a set in the Rhode Island School of Design Museum (Gift of Mr. and Mrs. Sigmund J. Katz, 57.198), which consists of a coffeepot, a teapot, a creamer, a sugar bowl, a tea caddy, six coffee cups, six teacups, twelve saucers, and a spoon rest. It is interesting to note that it is titled a "tea service."

7. Gottlieb Siegmund Corvinus, *Nutzbares, galantes und curiöses Frauenzimmer-Lexicon* (Leipzig, 1715).

8. As Christina Nelson has noted, "the average beverage service usually included six cups and saucers, a coffee pot, a teapot, a waste bowl, a tea canister, a sugar bowl, and a milk jug; larger services included a chocolate pot and six chocolate cups; coffee and teaspoons could be ordered to match." See Christina H. Nelson with Letitia Roberts, *A History of Eighteenth-Century German Porcelain: The Warda Stevens Stout Collection* (Memphis and Easthampton, MA, 2013), 243.

9. See accession documentation in 62.86 curatorial file, European Art, Detroit Institute of Arts.

10. See, for example, Victoria & Albert Museum, C.49&A – 1956.

11. See, for example, Victoria & Albert Museum, C.1525&A – 1919.

12. I am grateful to Dr. Christian Lechelt of Porzellanmanufaktur FÜRSTENBERG GmbH for the brilliant identification of the topographic scenes and the suggestion that Weitsch might be the painter. Christian Lechelt to Yao-Fen You, email, August 19, 2015.

13. "Komplettes glattes Kaffee- und Teeservice (12 Tassen, 5 große Stücke), purpur Landschaften und vergoldet=40 Taler." See Beatrix Freifrau Wolff Metternich and Manfred Meinz, *Die Porzellanmanufaktur Fürstenberg. Eine Kulturgeschichte im Spiegel des Furstenberger Porzellans* (Berlin, 2004), 1:79.

14. Robert Liberles, *Jews Welcome Coffee* (Waltham, MA, 2012), 23.

15. Quoted in Markman Ellis, Richard Coulton, and Matthew Mauger, *The Empire of Tea: The Asian Leaf That Conquered the World* (London, 2015), 45. By 1681, Bontekoe had moved to Hamburg at the invitation of Frederick William I, Elector of Brandenburg. For the German translation, see Cornelis Bontekoe, "Drei neue curieuse Tractägen von dem Brand Café, Chinesischen The und der Chocolata," in *Kurze Abhandlung von dem menschlichen Leben, Gesundheit, Krankheit und Tod* (Rudolstadt, 1692). For further discussion of Bontekoe, whose medical views were quite controversial, see Jonathan Israel, "Enlightenment, Radical Enlightenment and the 'Medical Revolution,'" in *Medicine and Religion in Enlightenment Europe*, edited by Ole Peter Grell and Andrew Cunningham (Aldershot, UK, 2007), 5 – 28; cf. Christoph Schweikardt, "More Than Just a Propagandist for Tea: Religious Argument and Advice on a Healthy Life in the Work of the Dutch Physician Cornelis Bontekoe (1647 – 1685)," *Medical History* 47 (2003): 357 – 68.

16. Michael North, *Material Delight and the Joy of Living: Cultural Consumption in the Age of Enlightenment in Germany*, translated by Pamela Selwyn (Aldershot, UK, and Burlington, VT, 2008), 161.

17. Ibid., 157 – 59.

18. See Lechelt to You, email, August 8, 2015.

19. Corvinus 1715, 2007. "Terra sigillata" is most likely a reference to what we call Böttger stoneware. "Hänlein" is difficult to translate. It does not show up in any of the major eighteenth-century German dictionaries, but I assume it is the diminutive form of "Hähne," which appears in the probate inventory of Anna Plaehn of Hamburg in reference to one of her coffee urns: "Eine

Coffée-Kanne, mit drey Hähne [Messing]."
(Translated as "one coffeepot with three
spigots [brass]"). Quoted in North 2008, 164,
224, n. 36.

20. Bennett Alan Weinberg, *The World of
Caffeine: The Science and Culture of the World's
Most Popular Drug* (New York, 2001), 86.

21. For further discussion, see Peter
Albrecht, "Coffee-Drinking as a Symbol
of Social Change in Continental Europe in
the Seventeenth and Eighteenth Centuries,"
Studies in Eighteenth-Century Culture 18
(1988): 91–103.

22. Quoted in North 2008, 166.

23. See Peter Albrecht, "Kaffee, Tee,
Schokolade und das echte Porzellan," in
*Weißes Gold aus Fürstenberg: Kulturgeschichte
im Spiegel des Porzellans 1747–1830*, edited by
Angelika Lorenz (Münster and Braunschweig,
1988), 38–52, esp. 47–48.

24. Quoted in North 2008, 166–67.
Reß's collected works can be found in *Johann
Heinrich Reß: Sammlung einiger kleinen größten-
theils landwirtschaftlichen Aufsätze* (Leipzig,
1790).

25. See Albrecht 1988, 96–98.

26. Quoted in North 2008, 162–63.

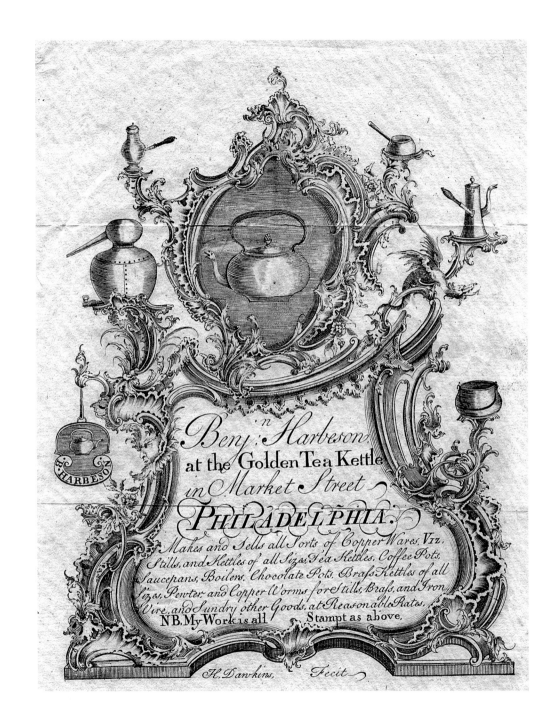

Benj: Harbeson,
at the Golden Tea Kettle
in Market Street
PHILADELPHIA.

Makes and Sells all Sorts of Copper Wares, Viz.
Stills, and Kettles of all Sizes, Tea Kettles, Coffee Pots,
Saucepans, Boilers, Chocolate Pots, Brass Kettles of all
Sizes, Pewter and Copper Worms for Stills, Brass, and Iron
Wire, and Sundry other Goods, at Reasonable Rates.
NB. My Work is all Stampt as above.

H. Dawkins, Fecit

B. HARBESON

MIMI HELLMAN

Making Coffee at Home in America: Episodes in the Cultural History of Design

IN 1872, A BOOK about the history of coffee declared: "The best method of preparing a beverage from coffee, or, as it is termed, *making coffee*, is a subject that has received a good deal of attention."[1] Despite this claim of awareness, the pointed phrasing suggests that turning seeds from a tropical shrub into an appetizing drink was still a relatively new practice in American homes.[2]

This essay offers an episodic history of coffeepots in the United States between the colonial period and the present.[3] Focusing on objects that were considered particularly innovative, it explores how their design, usage, and promotion helped to shape consumers' identities and conceptions of coffee as a substance. Vessels for brewing and serving not only enabled people to incorporate coffee drinking into domestic routines, they also facilitated its transformation into a socially potent drink that was "at home" in America.

CIVILIZING THE SUBSTANCE

Coffee began circulating in the North American colonies during the mid-seventeenth century, and by the late eighteenth century it accompanied social interaction in many prosperous households.[4] In 1775, Continental Congress delegate and future U.S. president John Adams described coffee parties as occasions for "many sprightly Conversations."[5] The beverage acquired moral legitimacy as an alternative to alcohol and patriotic associations as an alternative to British-controlled tea. Yet it still was regarded as foreign, and uncertainty prevailed regarding its physical effects. One treatise warned that coffee caused stomach problems, nervous disorders, and tuberculosis, while another praised "tonic and invigorating qualities" that resolved asthma and menstrual irregularity.[6]

Fig. 1. Henry Dawkins, *Trade card of Benjamin Harbeson*, ca. 1776. The Winterthur Library: Joseph Downs Collection of Manuscripts and Printed Ephemera

Uncertainty also informed the preparation process. Beans of variable freshness were roasted unevenly in a skillet or in the oven, then crushed to irregular fineness in a manual grinder and boiled in water. Consumers probably found the result unpleasantly bitter, and may have associated it with the concentrated, unfiltered coffee appreciated in Middle Eastern cultures. This connection could be both fascinating and disturbing, as in the case of one author who explained that Turks drank coffee to recover from "amorous pleasures" fueled by opium.[7]

Two trends in Euro-American coffee making helped to counter this material and conceptual instability. The first was a preoccupation with removing the grounds prior to serving. A brew was considered tasty and healthy only if "bright and clear, and entirely exempt from the least cloudiness or foul appearance." One that retained any trace of its "gross origin" in the bean was indigestible and "disgusting to the palate."[8] Westerners also added milk and sugar. By reversing coffee's dark color and bitter taste with the help of a local product associated with nourishment, as well as another imported commodity associated with colonial power and social privilege, consumers domesticated a problematic substance.[9]

The design of coffeepots also contributed to this process. The trade card of metalsmith Benjamin Harbeson (fig. 1) presents a variety of housewares as simultaneously exotic and accessible. Objects perch on brackets extending from an elaborate framework, including (at the upper right) a conical coffeepot with its straight handle set at a right angle to the spout.[10] A rococo vocabulary of scrollwork, foliage, and fanciful creatures casts the goods as ornamental curiosities displayed on pedestals. At the same time, their sturdy forms stand out clearly against the blank background, handles extended, as if ready to be plucked and taken home.[11]

The type of pot depicted on Harbeson's card was designed for both boiling and serving coffee. In many affluent households, however, the drink was prepared in the kitchen and transferred to a more ornate serving vessel. This further distanced consumers from the substance and enhanced their ability to define identities through objects. Simply displaying an elegant coffeepot in one's home could express wealth and worldliness; using it enabled active demonstrations of status. Elite individuals were expected to conduct themselves with grace and self-control, which meant handling tableware carefully. According to one guide, a vulgar man "scalds his mouth, drops either the cup

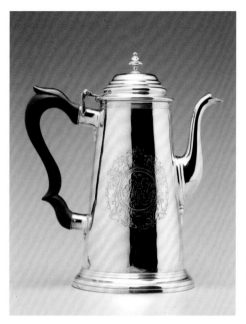

Fig. 2. John Burt, *Coffeepot*, ca. 1725/45, silver. Detroit Institute of Arts, Founders Society Purchase, Gibbs-Williams Fund, 37.190

or the saucer, and spills the tea or coffee in his lap."[12] Objects signified not only through their design but also by facilitating—or foiling—the performance of refinement.

Consider a silver pot made by John Burt (fig. 2). The flaring ebony handle enabled graceful pouring by providing a firm grip that kept one's hand from touching hot metal. A family crest proclaimed the owner's status. So did the smooth, polished surface, for keeping silver in such condition required servants' labor. Silver wares encoded significant roles and relationships, often serving as wedding gifts and tokens of friendship or achievement.[13] They also were considered both liquid assets and legacies for future generations. The head of a prominent Virginia family captured this spectrum of meanings: "I esteem it as well politic as reputable to furnish myself with an hansom Cupboard of plate which gives my self the present use & Credit, is a sure friend at a dead lift . . . or is a certain portion for a Child after my decease."[14]

An earthenware pot shaped like a pineapple (cat. 26) conferred prestige through different associations.[15] Eighteenth-century Americans encountered this luxurious fruit as a motif in architecture and decorative art, and a wealthy

few enjoyed the real thing.[16] Horticulturalists marveled at its striking appearance and distinctive taste; one noted that it "cannot fail of striking a contemplative mind with admiration."[17] The coffeepot cleverly linked two foreign commodities known for contrasting qualities: the golden, luscious fruit dispensed a beverage that started out brown, bitter, and grainy, then was rendered lighter, sweeter, and smoother. Such tensions probably enhanced consumers' enjoyment of both coffee's exoticism and its westernized taste.

Design thus played an important role in coffee's integration into American life. Elegant, expertly handled containers aestheticized their contents and valorized their users, helping to turn a foreign substance into a sign of cultural authority.

CODIFYING SERVICE

During the nineteenth century, coffee became available to a much wider range of consumers. Especially after the Civil War, the industrialization of cultivation, roasting, and packaging began to yield a fresher, more consistent product. An expanding mass media facilitated companies' efforts to define brands and encourage consumer loyalty.[18]

The gradual stabilization of coffee as a substance occurred amid continuing debates about its material qualities and physical effects. Many publications warned of dangerous adulterants.[19] Experts often gauged healthfulness in relation to preparation methods. One warned: "The very same ingredients may be injurious and depressing, or wholesome and exhilarating, according to the way in which they are treated." A brew could energize both mind and body, and provide relief from whooping cough or cholera, but it also could induce "irritability of temper . . . a kind of intoxication ending in delirium, and great injury to the spinal function."[20]

Most commentators agreed that one should never ingest coffee grounds. Some framed this view explicitly in relation to cultural, racial, and religious differences, distancing American consumers (imagined as Caucasian and Christian) from those of the Arab world. The same source quoted above noted that "Americans generally prefer not to absorb the substance of the berry as do the followers of Mahomet," and declared that "as rich, fragrant, clear coffee is no more expensive than strong coffee — *thick and muddy, bitter*, but not fragrant — there is no reason why every one should not revel in the simple

Fig. 3. Currier & Ives, "A Fragrant Cup," 1884. Museum of the City of New York

luxury."[21] Such language cast coffee as a heretical, dirty substance that needed to be made pleasing and safe.

A chromolithograph from the 1880s (fig. 3) visualizes this process of domestication. The balanced composition presents a sturdy coffee urn as the fourth member of a fair-skinned, healthy looking family, and offers a space in which the viewer can imagine sitting. Sugar and milk stand ready to modify the brew, which already looks unrealistically pale. Visual cues present the woman as nurturer: her hands align with the urn and a large cup, while her rounded, lace-trimmed form echoes that of the sugar bowl. The figures model proper decorum, which included lifting cups only by their handles, taking small sips, and not drinking from saucers.[22] A verse caption frames their beverage choice as virtuous resistance to alcohol.[23] As a widely circulating, affordable piece of popular visual culture, this image contributed to the naturalization of both coffee drinking and a particular conception of the American family.

Fig. 4. Fletcher and Gardiner, *Coffee and Tea Service*, ca. 1815, silver and ebony. Detroit Institute of Arts, Museum Purchase, with gift of funds by various donors, 2002.136.1–5

Fig. 5. Gorham Manufacturing Co., *Coffee and Tea Service Vessels*, 1881, sterling silver, parcel-gilt, and ivory. Detroit Institute of Arts, Founders Society Purchase, with gift of funds by various donors, 80.94.1–5

Fig. 6. Wurts Brothers, *Mrs. Lyman and Miss Hazen, illustrating coffee percolator*, ca. 1915, gelatin dry plate negative. Museum of the City of New York

Prosperous households maintained the separation of brewing and serving, and the latter acquired greater visual unity and new kinds of prestige through the increasing availability of matching silver sets (figs. 4–5).[24] The Industrial Revolution enabled changes in silver mining and manufacturing that made it possible for a middle-class family to own one of these ensembles—or at least a more affordable set of electroplated wares that looked like solid silver and carried the same "mien of nobility."[25] As in the eighteenth century, silver objects required laborious maintenance, marked milestones in people's lives, and became treasured heirlooms. Now a broader range of consumers could tap their significance.

Paradoxically, this democratization of luxury intensified the social stakes of choosing and using beverage services. As ownership became common, aesthetic discernment and proper conduct became more nuanced means of presenting oneself as a refined consumer rather than one driven by greed. A magazine article of 1874 encouraged readers to regard fine silver as "fit rather for a picture-gallery, than for the vulgar service of the body."[26] Conduct manuals

explained how to serve coffee in various circumstances, from family breakfasts to formal dinners and receptions.[27] Degrees of proficiency with these protocols positioned consumers on a social spectrum. A codification of sweetened black coffee as the appropriate after-dinner drink may indicate growing comfort with the substance, but it also pressured hosts to provide an acceptably clear brew and guests to show appreciation for its taste.

Within the format of the beverage service, styles could carry different meanings. An example produced by Fletcher and Gardiner around 1815 (fig. 4) and one made at the Gorham manufactory in 1881 (fig. 5) embodied historically specific values. Fletcher and Gardiner's set employs a neoclassical vocabulary that, for several decades after the American Revolution, linked American culture with idealized conceptions of ancient Greece and Rome. At the same time, motifs such as acorn finials, handles shaped like laurel-crowned heads, and spouts terminating in eagle's heads invited patriotic associations with the endurance, glory, and power of the young United States.[28] Indeed, the talon feet and eagle spouts on the two pots Americanized coffee and tea in a quite tangible way: imported beverages flowed from the body of a national symbol.

In contrast, the Gorham service (fig. 5) uses an orientalist idiom favored during the late nineteenth century. Objects inspired by motifs and techniques from Asia and the Middle East, reinterpreted and combined in distinctively Western ways, defined their owners as worldly, discerning individuals who eschewed the conformism of mainstream consumer culture.[29] The Gorham example appealed to such sensibilities through virtuoso workmanship and a clever design conceit: the vessels' hammered surfaces appear to be cracking open to reveal woven baskets filled with flowers. Whereas the neoclassical service (fig. 4) imagined coffee drinking as a patriotic act, this one encouraged a fantasy of exotic ritual.[30] The shift might seem contrary to the domestication process (fig. 3), but the phenomena were interdependent. As coffee became increasingly Americanized, its foreign associations more readily evoked pleasure and prestige.

PERFORMING THE BREW

American coffee consumption increased steadily during the first half of the twentieth century. Producers asserted ever-greater control over cultivation and processing, even as debates about healthfulness continued.[31] Silver services still carried prestige and appeared in modern styles. But the most impactful design innovations were technologically specialized devices that could be used for both

brewing and serving, and that claimed to improve upon the traditional practice of boiling grounds in a simple pot.

The first such invention to be widely marketed in the United States was the percolator, which worked by saturating grounds multiple times with recirculated hot water. Advocates stressed percolation's ease, speed, economy, and consistency, and often stigmatized boiled coffee in the culturally loaded terms of previous centuries: dark, strong, contaminated by sediment, and therefore unhealthy. In 1912, for instance, Manning-Bowman announced that a stovetop percolator "extracts the fragrant, aromatic qualities . . . and *leaves behind* the bitter, nerve-wracking elements" to yield "a clear, delicious beverage . . . a veritable revelation to one who has known only the old-time coffee pot."[32]

Percolators heated by alcohol or gas lamps brought coffee making into social spaces, closing the longstanding gap between preparation and presentation. Family and guests could now savor the heady smell and bubbling sound of brewing coffee, perhaps glimpsing the process through a finial or upper chamber made of glass. But these new pleasures entailed new pressures. Making coffee in the dining room emphasized a housewife's responsibility (as opposed to that of a servant) for properly manipulating a pot capable of yielding an acceptable beverage. A photograph made around 1915 (fig. 6) suggests the expertise now required for brewing as well as serving.[33] Two fashionably dressed women focus intently on an urn-style percolator. While one watches, cup and biscuit momentarily forgotten, the other delicately turns the spigot and holds her own cup with an elegantly extended pinky.

Brewing at the table became even more widespread with the development of electric percolators. Within a larger discourse that reimagined domestic work in scientific terms, these devices were hailed as tools that reduced kitchen toil, impressed guests, and fostered family well-being.[34] A housekeeping manual deemed them "quick, simple to operate, pretty in action, free from smell and dirt."[35] A Westinghouse advertisement proclaimed that "new pleasures surround the meal-time . . . No steps to take, no fire to light. Everything hot. Everything handy."[36] A competitor attached emotional value to sound: "How much more interesting and intimately appealing is any meal when the cheerful blub, blub of a Hotpoint Percolator is added."[37] And Manning-Bowman allayed technophobia by stressing safety features like automatic cut-off switches, promising that their obedient pot "*never* works at the *wrong* time and *never fails* at the *right time*."[38]

Many designs for electric percolators contributed to this assurance of consumer comfort by employing traditional forms. An advertisement for Landers, Frary & Clark's line of 1928 (fig. 7) features chromium-plated items whose neoclassical style recalls eighteenth- and nineteenth-century precedents. Echoing attitudes toward silver heirlooms, the caption distances possession from the stigma of materialism by stressing quality, "inspiring beauty," and endorsement by "hostesses the world over." These attributes allow a "proud owner" to display her wares with "pardonable pride."[39] Ownership even carries patriotic associations, for the service is named for the Marquis de Lafayette, a hero of the American Revolution whose portrait hovers above the milk pitcher.

Fig. 7. Advertisement for Landers, Frary & Clark "Universal" appliances, *Good Housekeeping* 87 (November 1928), 282. Skidmore College Visual Resources Collection

Fig. 8. Silex coffeepot advertisement from *Good Housekeeping* 63 (September 1916), 172. The Silex Company. From the Periodicals Collection, Sophia Smith Collection, Smith College (Northampton, Massachusetts)

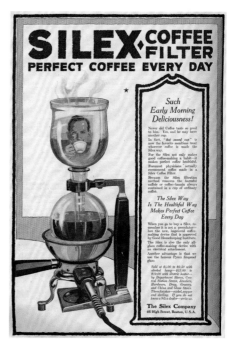

Historical legitimacy also emerges in the company's identification as longtime "Master Metalsmiths," a claim that belies the realities of industrial manufacture. And although several verbal references to electricity indicate its importance, the imagery avoids it. Only one pot sports an electric cord, discreetly tucked behind its colonial-inspired body. Paradoxically, this celebration of a quintessentially modern device reveals considerable ambivalence about change.

In contrast, another kind of table-top coffee maker embraced an overtly technological aesthetic. The vacuum pot, first popularized by Silex in the mid-1910s (fig. 8), brewed coffee in a two-part vessel of heatproof glass mounted on a stand. Vapor pressure forced hot water from the lower chamber into the upper one, where it mixed with ground beans. When the heat was cut off, the brew descended through a fabric filter; one then set aside the top chamber and poured using the stand as a handle.[40]

Rejecting nostalgia for heirlooms, a Silex conjured the rationality and innovative potential of laboratory equipment. Advertisements called it a "machine" or "device," encouraging consumers to relish the manipulation of electricity.[41] In figure 8, a sturdy plug extends toward the viewer, echoing the emphatically rendered handles of the pot and its heating element. The full-page composition virtually places the apparatus into the magazine reader's hands, urging her to imagine herself as an accomplished domestic technician. The caption builds further confidence by aligning her expertise with that of professionals, the Good Housekeeping Institute, and "foremost physicians."[42]

By making the entire brewing process visible, the Silex popularized a more dynamic relationship with coffee as substance. Consumers could now enjoy orchestrating and watching—as well as hearing and smelling—the interaction of water and grounds. But apart from a novel design and the alleged health benefits of glass over metal, the case for Silex brewing maintained established criteria for good coffee. Promoters promised fast, reliable, aromatic results with no bitterness.[43] The aversion to ingesting grounds not only remained but became more pronounced than ever: one could now *see* the beans yield up their essence while remaining trapped in the upper chamber. As one advertisement put it, the vigilant pot allowed "no opportunity for sediment to seep through."[44]

Furthermore, although the notion of housewives as technicians offered women a more modern form of agency than a "hostess" with a Lafayette service, the Silex still demanded performative proficiency and was associated with

normative gender roles. The visual stability of figure 8 denies the awkwardness of handling the actual object, which involved detaching the hot, messy top section and lifting the whole stand when pouring.[45] It also suggests that by mastering her coffeepot, a woman secured male approval and domestic concord. Floating like a vision in the vessel's upper chamber, a man's face smiles behind a cup of what the caption calls "Early Morning Deliciousness," a drink so healthy and satisfying that "he may have another cup."[46] Like her Victorian predecessor (fig. 3), the owner of a Silex was expected to serve others.

REIMAGINING CONSUMERS

By the final third of the twentieth century, coffee making was ubiquitous in American homes. In a market brimming with options for both brewing devices and the product itself, social distinction required new codes. Interest in specialty coffees, home grinding, and preparation methods long popular in Europe became ways for consumers to express sophistication.[47]

 The most significant design development was the automatic drip machine, introduced in 1972 by North American Systems under the brand name Mr.

Fig. 9. North American Systems, Mr. Coffee automatic drip coffee maker, "Coffee Saver" model MCS200, first issued 1976. Skidmore College Visual Resources Collection

Coffee (fig. 9). These appliances sprayed hot water over a paper-lined filter filled with grounds and dispensed the brew into a glass carafe set on a hot plate. Although marketed as an improvement over percolators and vacuum pots, their merits sounded the same: convenience, speed, smooth taste, clear brew.[48] The design might seem unconducive to social performance, returning coffee making to the kitchen and requiring no expert manipulation, but these very factors carried value. Kitchens had become spaces for eating and social-izing, entertaining was more casual, and women were resisting traditional roles and working more outside the home. By flipping switches, attending to other things during the quick brewing cycle, and serving from an unelaborate pot, users defined themselves in late modern terms: busy, spontaneous, and at ease with technology.

The Mr. Coffee "Coffee Saver" model (fig. 9), developed in 1976 in response to rising bean prices, promised integration into kitchen routines. The plastic housing complemented cabinetry with its blocky shape, drawer-like filter basket, and combination of plain white and simulated wood-grain finishes. Prominent switches and red lights made it simple to control brewing, warm-ing, and filter width (the "coffee saver" feature, to maximize saturation when making a partial pot). And although the design kept brewing out of view, it still aestheticized the result. Coffee flowed from a brown receptacle into a clear pot enlivened by white flowers and backed by a white surface. These features enhanced its apparent richness and clarity—or perhaps revealed an undesirable lack thereof.

Advertisements for Mr. Coffee opened up the possibility that brew-ing could be an equitably gendered practice. They appealed to both men and women by personifying the machine as a strong, reliable, masculine house-hold assistant.[49] The treatment of gender in a television spot for the coffee-saver model favors similarity over difference.[50] It opens with alternating shots of the object and young couple smiling over steaming mugs. Although a male voice provides authoritative narration and a woman's hand briefly demon-strates key features, the sequence does not explicitly cast the owner-operator as a housewife or hostess, or even necessarily as married. The two actors sport similar hairstyles and clothing, and symmetrical framing enhances their resem-blance. The spot ends with a dissolve (fig. 10) that turns the couple's paired, backlit heads into a similarly composed and lit view of the machine. This visually balanced presentation of coffee as a catalyst for domestic harmony

Fig. 10. Still from television advertisement for Mr. Coffee automatic drip coffee maker, "Coffee Saver" model MCS200, 1976

retains Victorian traces (fig. 3), but women are no longer charged with nurturing others.

In 2016, specialty coffees have become staples and no single brewing method prevails. Claims about health effects still vary; suspicions about bean origin and processing now play out through debates about sustainability and fair trade. The longstanding preoccupation with controlling and customizing coffee making has acquired new intensity in the form of programmable machines that extract individual drinks from capsules. Despite the popularization of espresso, many consumers continue to favor a sediment-free brew tempered by sugar and milk.[51]

Perhaps the most socially interesting trend in brewing practice is the AeroPress (fig. 11). It was created not by a corporate designer but rather through off-duty tinkering by a mechanical engineer named Alan Adler, who wanted a simple device for making small quantities of coffee. The result was a plastic tube with a paper-lined filter in the base and a sturdy plunger. After

balancing the tube on a cup or carafe and filling it with ground beans and hot water, one presses the plunger to dispense a concentrated drink. Sold with accessories (scoop, stirrer, funnel, and filter dispenser), the AeroPress resembles a tool kit or toy set.[52]

Claims for this device reiterate familiar values: simplicity, speed, and consistency in producing coffee free of bitterness or sediment.[53] Yet the design and advertising rhetoric reject the technological feats that characterized twentieth-century methods and continue to inspire electronic machines. One magazine praises the AeroPress's "old-fashioned approach" along with those of a corded telephone and a record turntable.[54] The object also enables an unusually flexible, intimate integration of coffee preparation into various spaces of everyday life. It fits comfortably in the hands, encourages sensory appreciation, and transports easily for use outside the home.

Yet the AeroPress hardly rejects the performativity of coffee making. It requires proficiency: one must handle small pieces, plunge gently, and ensure that it does not overflow or tip over. Some people raise the stakes with a tricky "inverted method," brewing with the tube upside-down and flipping it before plunging. Moreover, AeroPressing has become a popular spectacle in

Fig. 11. Aerobie, Inc., AeroPress coffee-making kit, 2015

Fig. 12. Dave and Quin Cheung, Screen shot from AeroPress demonstration video, YouTube channel "Not So Ancient Chinese Secrets," 2014

coffee bars, at elaborately staged competitions, and through internet videos. In these contexts, users around the world present their expertise to a wide audience. They share opinions about numerous variables: types and quantities of beans and bottled water; grind texture and water temperature; infusion duration; methods for pouring, stirring, and plunging. They employ scales, timers, manual grinders, and special kettles.[55] Such tactics foster coffee connoisseurship, garnering prestige for those who can discern qualities such as "caramel notes, burnt marshmallow undertones, hints of smoke, and dark chocolate."[56]

Compared with traditional advertising campaigns, AeroPress videos feature a greater range of social personas, settings, and visual idioms. The spokespeople, a mix of home users and professional baristas or retailers, present themselves as individuals with distinctive, often quirky sensibilities. They include men and women of various ages and nationalities. Brewing takes many forms: a ritual, a game, a quick fix at work or play, an erotic tease. Some videos employ professional stylistic codes; many suggest amateur candor through qualities such as wobbly framing and uneven sound.[57] The Canadian blogger Dave Cheung combines polished production values with a spontaneous manner

(fig. 12).[58] A low camera angle and tight framing at once monumentalize the equipment and create a sense of intimacy. Cheung leans into the camera, speaking in a lively, familiar tone that assures accessibility even as he models a highly proficient routine.

AeroPress culture simultaneously publicizes and privatizes coffee making. It celebrates individual preferences through widely available performances that are selected and viewed on the screens of personal devices. The variety seems to defy norms, proposing a diverse, global community of consumers who claim their own expertise rather than receiving instructions from institutionalized authorities. But capitalist interests pervade this arena of imagined freedom, with every video trailing advertisements and competitions supported by corporate sponsors.[59] In addition, some imagery complicates the AeroPress's supposedly ungendered appeal by masculinizing the already phallic device through associations with confrontational behavior and extreme athleticism.[60]

MAKING COFFEE, MAKING MEANING

The design history of coffee making is a history of changing forms and functions that encode social values. Some of the broad developments sketched here include the democratization of luxury; the popularization of specialized, individualized devices that combine brewing with serving; and a shift from fantasies of feminized domesticity to those of diversified collectivity. Certain preoccupations have persisted, notably the social value of performance and ambivalence toward the materiality of the bean.

A final example suggests how some design projects not only shape coffee-making practices but actively critique their underlying myths. Stanley Tigerman's silver service (fig. 13) was part of a 1983 project commissioned by Alessi.[61] It conforms to a conventional format, but details disconcert. Spouts look like parted lips (fig. 14); handles resemble hair styled in thick braids or a jaunty ponytail; the sugar bowl has ears. Hands grasp the tray as if someone is trapped underneath. While the gleaming, artificial silver distances these elements somewhat from their bodily referents, their naturalistic sizes and textures elicit a visceral response in which amusement vies with unease, if not revulsion.

Although Tigerman's service could be used, its main purpose is conceptual. The anthropomorphized ensemble invokes the stereotypical housewife-hostess whose charms figure so prominently in the social history of both coffee and tea. It also returns a sense of fascination and aversion to beverages that

Fig. 13. Stanley Tigerman for Alessi, *Coffee and Tea Service*, 1983. Detroit Institute of Arts, Founders Society Purchase, with gift of funds by various donors, 1986.30.1–5

Fig. 14. Detail of figure 13

have long been naturalized in American homes. And it urges us to remember that serving containers are not simply helpful housewares but active agents that confer meaning on both their contents and their users. To rework the claim of 1872 cited at the beginning of this essay, *making coffee* is a subject that still merits a great deal more attention.

This essay is dedicated to my father, Barry Hellman, and his sweetheart, Lois Miraglia, with whom I have enjoyed many great conversations over cups of coffee.

1. Robert Hewitt, Jr., *Coffee: Its History, Cultivation, and Uses* (New York, 1872), 77.

2. Coffee beans are dried seeds from the cherrylike fruit of a shrub native to Ethiopia. Already cultivated in the Arabian Peninsula by 1000 C.E., coffee was widely consumed around the Middle East by the sixteenth century. It began to circulate in Europe in the early seventeenth century and became an increasingly lucrative colonial crop dependent on slavery and indentured labor. Useful surveys include Mark Pendergrast, *Uncommon Grounds: The History of Coffee and How It Transformed Our World* (New York, 1999); Catherine M. Tucker, *Coffee Culture: Local Experiences, Global Connections* (New York and Abingdon, Oxfordshire, 2011); Robert W. Thurston et al., *Coffee: A Comprehensive Guide to the Bean, the Beverage, and the Industry* (Lanham, MD, 2013); James Hoffmann, *The World Atlas of Coffee: From Beans to Brewing—Coffees Explored, Explained, and Enjoyed* (Buffalo and Richmond Hill, Ontario, 2014).

3. For a pictorial survey of objects from the United States and Europe, see Edward and Joan Bramah, *Coffee Makers: 300 Years of Art and Design* (London, 1989).

4. The westernization of coffee occurred in tandem with that of tea from China and chocolate from Mesoamerica. For an overview of this phenomenon, see Jordan Goodman, "Excitantia: Or, How Enlightenment Europe Took to Soft Drugs," in *Consuming Habits: Drugs in History and Anthropology*, edited by Jordan Goodman et al. (London and New York, 1995), 126–47. Most of the coffee consumed in eighteenth-century North America came from the British- and French-controlled regions of the Caribbean. Steven Topik and Michelle Craig McDonald, "Why Americans Drink Coffee: The Boston Tea Party or Brazilian Slavery?" in Thurston et al. 2013, 234–47; Keith Stavely and Kathleen Fitzgerald, *America's Founding Food: The Story of New England Cooking* (Chapel Hill and London, 2004), 266–77.

5. John Adams to Abigail Adams, 3 December 1775, from Massachusetts Historical Society, *Adams Family Papers: An Electronic Archive*, http://www.masshist.org/digitaladams [accessed October 17, 2015]; orthography as in the original.

6. Samuel Solomon, *A Guide to Health, or Advice to Both Sexes* (New York, ca. 1800), 28, 44, 49, 69; Benjamin Moseley, *Treatise Concerning the Properties and Effects of Coffee* (Philadelphia, 1796), 27–41, quotation at p. 27. Both of these works circulated in earlier editions.

7. Moseley 1796, 35.

8. Moseley 1796, 43–44, emphasis in the original. Methods for clarifying boiled coffee, which continued to be used during the nineteenth century, included adding cold water to make the grounds settle, coagulating them with egg (shell included) or fish skin for easy removal, and passing the brew through a fabric filter.

9. Tea was modified in the same ways. The additives have their own histories: Andrew F. Smith, *Sugar: A Global History* (London, 2015), esp. 21–43; Andrea S. Wiley, *Cultures of Milk: The Biology and Meaning of Dairy Products in the United States and India* (Cambridge, MA, and London, 2014), esp. 25–52.

10. The other items in the image include a rotund distilling kettle with a spigot and probably (at the upper left) a chocolate pot.

11. Robert Jay, *The Trade Card in Nineteenth-Century America* (Columbia, MO, 1987), 9. The rococo framework was taken from an English model, but this would not have been known to American consumers.

12. J. Hamilton Moore, *The Young Gentleman and Lady's Monitor* (New York, 1800), 188.

13. Barbara McLean and Gerald W. R. Ward, *Silver in American Life: Selections from the Mabel Garvan and Other Collections at Yale University* (Boston, 1979); Michael K. Brown, "The Colonial Period," in *Marks of Achievement: Four Centuries of American Presentation Silver,* edited by David B. Warren et al. (New York, 1987), 23–31.

14. Correspondence of William Fitzhugh [1688], quoted in Ian M. G. Quimby, *American Silver at Winterthur* (Winterthur, DE, 1995), 5; orthography as in the original. "Dead lift" refers to a desperate situation.

15. The illustrated example resembles coffee- and teapots from Staffordshire, England, exported to North America during the 1760s, as well as similar wares made by colonial producers. Leslie B. Grigsby, "British Earthenware and Porcelain in Eighteenth-Century America," in *Welsh Ceramics in Context*, edited by Jonathan Gray, part II (Swansea, 2005), 71–91; Lisa Hudgins, "Staffordshire in America: The Wares of John Bartlam at Cain Hoy, 1765–1770," *Ceramics in America* (2009): 68–80.

16. By the mid-eighteenth century, this New World fruit was widely cultivated in tropical European colonies and came to North America from the West Indies. Kaori O'Connor, *Pineapple: A Global History* (London, 2013), 60–65; Michael Olmert, "The Hospitable Pineapple," *Colonial Williamsburg: The Journal of the Colonial Williamsburg Foundation* 20 (winter 1997–98): 47–57.

17. Temple Henry Croker et al., *Dictionary of Arts and Sciences, in which the Whole Circle of Human Learning is Explained* (London, 1766), no pagination, s.v. "Ananas." See also Adam Taylor, *A Treatise on the Ananas or Pine-Apple* (London, 1769).

18. Per capita consumption rose from less than a pound in the 1770s to nine pounds in the 1880s. Most of the nineteenth-century supply came from the Caribbean and Latin America, especially Brazil, but most consumers were unaware of its origins. Topik and McDonald 2013, 240–44. Innovations during this period included preroasted beans (championed by Arbuckles and McLaughlin's, among others) and factory-sealed cans and bricks for packaging them (a major selling point for Chase & Sanborn). Pendergrast 1999, chaps. 3–4; Francis L. Fugate, *Arbuckles: The Coffee That Won the West* (El Paso, 1994).

19. Maria Parloa et al., *Six Cups of Coffee Prepared for the Public Palate by the Best Authorities on Coffee Making* (New York,

1887), 45–47; "Poison in Every Cup of Coffee. Dangerous Coloring Matter Used to Deceive the Public," *New York Times* (3 May 1884), 8; "A Coffee Adulterant. The Market Becoming Flooded with a Counterfeit Bean," *New York Times* (30 April 1891), 2. Contaminants included arsenic and lead.

20. Parloa 1887, 3, 47–48. This source compiles advice from six experts who recommend various methods, from rapid filtering to extended boiling, that produce quite different results.

21. Parloa 1887, 19, 30; orthography as in the original; my emphasis.

22. Nineteenth-century conduct manuals reframed the previous century's expectations to address a growing middle class. Other rules included not blowing on or slurping one's drink, not draining cups to the last drop, not asking for more, and placing the spoon on the saucer rather than leaving it in the cup. (Evidently the child in the chromolithograph has yet to master this last.) Maud C. Cooke, *Social Etiquette, or Manners and Customs of Polite Society* (Boston, 1896), 211–25; John F. Kasson, "Table Manners and the Control of Appetites," in his *Rudeness and Civility: Manners in Nineteenth-Century Urban America* (New York, 1990), 182–214.

23. The caption, inspired by the temperance movement, reads: "The truly blest are those, / Who scorning drinks pernicious, / May here refresh their souls, / With Coffee so delicious."

24. In accordance with a standard formula, each of the illustrated sets includes coffee- and teapots (identical except for the former's larger size), a milk pitcher, a lidded sugar bowl, and a waste bowl. Waste bowls

(also known as slop bowls) were used for discarding spent tea leaves prior to brewing a fresh pot, or for emptying dregs from cups before they were refilled.

25. Until the very end of the eighteenth century, most services were made of ceramics; silver coffeepots generally were singular objects or paired with teapots. For a survey of industrialized production, see Charles L. Venable, *Silver in America, 1840–1940: A Century of Splendor* (New York, 1995). For period accounts, see James Parton, "Silver and Silver Plate," *Harper's New Monthly Magazine* 37 (September 1868): 433–48; William C. Conant, "The Silver Age," *Scribner's Monthly, an Illustrated Magazine for the People* 9 (December 1874): 205.

26. Conant 1874, 208–9.

27. Cooke 1896, 197–203, 233, 274–75, 287–92, 296. It was customary for women to retire from the dinner table for coffee in the drawing room, where men would join them after indulging in smoking and additional drinking. Depending on the social situation, coffee might be poured by the hostess, by a female relative or favored friend, or by a servant (whose conduct carried implications for the hosts' own gentility).

28. Donald L. Fennimore and Ann K. Wagner, *Silversmiths to the Nation: Thomas Fletcher and Sidney Gardiner, 1808–1842* (Winterthur, DE, 2007), 58–79.

29. Venable 1995, 160–99; Charles H. Carpenter, Jr., *Gorham Silver 1831–1981* (New York, 1982), 94–106; David A. Hanks with Jennifer Toher, "Metalwork: An Eclectic Aesthetic," in *In Pursuit of Beauty: Americans and the Aesthetic Movement* [exh. cat., The Metropolitan Museum of Art] (New York,

1986), 253–93; Mari Yoshihara, *Embracing the East: White Women and American Orientalism* (Oxford, 2003).

30. Some nineteenth-century publications verbalized this fantasy. One (quoting an earlier author) called coffee drinking "the fragrant incense we proffer at the shrine of the social hearth—the delicious libation which we pour on the altar of friendship," and associated it with the world of *The Arabian Nights*. Hewitt 1872, 9, 18.

31. Per capita consumption peaked during the World War II period at around nineteen pounds, much of it from Brazil. Thurston in Thurston et al. 2013, 206. Mass marketing played a major role in coffee's popularity, along with the availability of factory- and store-ground beans. Pendergrast 1999, chaps. 5–12; Michael F. Jiménez, "'From Plantation to Cup': Coffee and Capitalism in the United States, 1830–1930," in *Coffee, Society, and Power in Latin America*, edited by William Roseberry et al. (Baltimore and London, 1995), 38–64.

32. Advertisement for Manning-Bowman percolator, *Life* 60 (7 November 1912), 2170. Percolators remained the most popular brewing devices in the United States until they were supplanted by automatic drip machines in the 1970s.

33. The device appears to be powered by gas line and may be a Manning-Bowman model.

34. Electricity began to become available in the 1910s but remained a privileged resource until after World War II. For its impact on home life, see David E. Nye, "A Clean, Well-Lighted Hearth," in his *Electrifying America: Social Meanings of a New Technology, 1880–1940* (Cambridge, MA, and London, 1990), 238–86. For the professionalization and commodification of housework, see Helen Zoe Veit, "A School for Wives: Home Economics and the Modern Housewife," in her *Modern Food, Moral Food: Self-Control, Science, and the Rise of Modern American Eating* (Chapel Hill, 2013), 77–100; Sherrie A. Inness, "Waffle Irons and Banana Mashers: Selling Mrs. Consumer on Electric Kitchen Gadgets," in her *Dinner Roles: American Women and Culinary Culture* (Iowa City, 2001), 71–87.

35. Maud Lancaster, *Electric Cooking, Heating, and Cleaning: A Manual of Electricity in the Service of the Home* (New York, 1914), 89.

36. Advertisement for Westinghouse appliances, *Good Housekeeping* 63 (December 1916): 193.

37. Advertisement for Hotpoint appliances, *Good Housekeeping* 65 (December 1917): 177.

38. Advertisement for Manning-Bowman percolators, *Good Housekeeping* 74 (April 1922): 189; emphasis in the original.

39. Advertisement for Landers, Frary & Clark "Universal" brand appliances, *Good Housekeeping* 87 (November 1928): 282.

40. The vacuum (or siphon) process was developed in Europe during the nineteenth century and known to American coffee experts during that period, but it did not become commercially viable in the United States until the early twentieth century. A stovetop version of the Silex replaced early models supplied with alcohol lamps or electric heaters, and remained in wide circulation until the mid-twentieth century. The method

currently is enjoying a revival among coffee enthusiasts, with several companies producing models that resemble the Silex.

41. Advertisements for Silex vacuum pots, *Good Housekeeping* 63 (September 1916): 172; *Good Housekeeping* 63 (November 1916): 197.

42. Advertisement for Silex vacuum pot, *Good Housekeeping* 63 (September 1916): 172. Some advertisements also included endorsements from restaurant, hotel, and club proprietors.

43. Advertisements for Silex vacuum pots, *American Homes and Gardens* 25 (May 1914): xviii; *Country Life in America* 27 (April 1915): 25; *Good Housekeeping* 63 (November 1916): 197; *Good Housekeeping* 65 (July 1917): 130.

44. Advertisement for Silex vacuum pot, *Good Housekeeping* 59 (July 1914): 139.

45. In 1917, a hinge was added that enabled users to rotate the serving chamber for pouring rather than picking up the entire object, but this only partly addressed the challenges of manipulation.

46. Advertisement for Silex vacuum pot, *Good Housekeeping* 63 (September 1916): 172. The floating head also could be perceived by a male viewer as his own reflection, but the advertisement's context in a women's magazine and its use of pronouns indicate that such an identification was not intended.

47. Per capita consumption declined during the decades after World War II to around six pounds, perhaps due in part to the increasing popularity of soft drinks. Thurston in Thurston et al. 2013, 206. Latin America, especially Brazil, remained lead producers. Water-soluble granules distanced consumers further than ever from the bean and probably contributed to the growing prestige of specialty coffees. Brewing devices with European associations included ceramic drip pots, stovetop "moka" pots, "French press" pots, and espresso machines. Pendergrast 1999, chaps. 13–17; William Roseberry, "The Rise of Yuppie Coffees and the Reimagination of Class in the United States," in *Food in the U.S.A.: A Reader*, edited by Carole M. Counihan (New York and London, 2002), 149–68. Health issues remained unresolved; see Bennett Alan Weinberg and Bonnie K. Bealer, *The World of Caffeine: The Science and Culture of the World's Most Popular Drug* (New York and London, 2001), 269–315.

48. Rebecca K. Shrumm, "Selling Mr. Coffee: Design, Gender, and the Branding of a Kitchen Appliance," *Winterthur Portfolio: A Journal of American Material Culture* 46 (winter 2012): 271–98.

49. Shrumm 2012. Much of the machine's supposed vigor was acquired by association with its most famous spokesperson, baseball player Joe DiMaggio. An advertisement reproduced by Shrumm (p. 272), depicting a couple enjoying their "coffee saver" machine beside a Christmas tree, appeared in concurrent issues of *Better Homes and Gardens* and the sportsman's magazine *Field and Stream*.

50. https://www.youtube.com/watch?v=cwIcY4ztU3w [accessed December 9, 2015].

51. For an overview of current production worldwide, see Hoffmann 2014, 118–247. A recent survey of brewing methods treats all devices impartially but provides a detailed explanation of how to prevent sediment—despite noting that this generally has no impact on taste. Lani Kingston, *How to Make Coffee: The Science behind the Bean* (New

York, 2015), 146. For recent debates about health and trade, see Tucker 2011, chaps. 10, 17–18; Thurston et al. 2013, chaps. 19–22, 56–58. For a case study of how fair-trade coffee is marketed to the millennial generation, see Paige West, "Making the Market: Specialty Coffee, Generational Pitches, and Papua New Guinea," *Antipode* 42 (2010): 690–718.

52. The invention story appears at http://www.aerobie.com/the-history-of-aerobie-inc/ [accessed December 9, 2015]. Interestingly, the company also makes throwing toys. An AeroPress produces one to four small portions that can be diluted with hot water or milk; the coffee is not true espresso because no strong piston pressure is involved.

53. In addition to these traits, the official description specifies that the device makes "regular American style coffee" as well as an espresso-like brew, and notes its health-conscious use of BPA- and phthalate-free material: http://www.aerobie.com/product/aeropress/ [accessed December 9, 2015].

54. Rojah Wilkerson, "Back to Basics: Simple Ways to Minimize a High-Tech Lifestyle," *Ebony* 70 (May 2015): 30.

55. Instructions online and in the box come in six languages besides English (Chinese, French, German, Japanese, Korean, and Spanish). The company's website encourages fans to submit videos, posting them alongside competition footage from numerous countries including Austria, Scotland, the Philippines, and Turkey. Competitions take place on many levels from local to international; see Emma Bowman, "How AeroPress Fans Are Hacking Their Way to a Better Cup of Coffee," Northeast Public Radio (April 16, 2015), at http://www.npr.org/sections/thesalt/2015/04/14/399337724/how-aeropress-fans-are-hacking-their-way-to-a-better-cup-of-coffee. For a montage of brewing methods, see https://www.youtube.com/watch?v=P7mWUGlczNo. For a demonstration by the 2015 world champion, Lukas Zahradnik of Slovakia, see https://www.youtube.com/watch?v=m3wKJo-WkDA [all accessed December 9, 2015].

56. Marissa Rothkopf Bates, "Gadget Lust: Power of the Press," *Newsweek Global* 161 (22 November 2013): 4.

57. Representing the retailer Kaffeologie, Bronwen Serna performs an elegant routine in a room accessorized by a vintage projector and typewriter: http://www.kaffeologie.com/s-filter-aeropress-inverted. Korean fan Junhwan Kim's point-of-view sequence takes place amid a clutter of toys: https://www.youtube.com/watch?v=1ogETFuzI1Q. In an unapologetically rough cellphone video, a tattooed fitness expert from Kentucky named Joe Daniels plunges coffee into an elephant-shaped mug: https://www.youtube.com/watch?v=idBdcQ_3IbE. A spokesperson for Stumptown Coffee Roasters brews in the woods beside a vintage camper: https://www.youtube.com watch?v=pmjPjZZRhNQ. Tim Wendelboe of Norway, one of the instigators of competition culture, offers a sexually suggestive homage: https://vimeo.com/16261120 [all accessed December 9, 2015].

58. Dave and Quin Cheung, https://www.youtube.com/watch?v=kQ8wvUKa35E [accessed December 9, 2015].

59. For the interplay between user creativity and corporate strategy, see Lev

Manovich, "The Practice of Everyday (Media) Life: From Mass Consumption to Mass Cultural Production?" *Critical Inquiry* 35 (winter 2009): 319–31. Thanks to Katherine Hauser for this reference.

60. This is especially evident in the visual analogies of competition posters, such as those for events in Milan and Scotland in 2014 (gun and Highland games caber toss, respectively), and Hong Kong in 2015 (handcuffs).

61. Eleven architects, mostly Americans, participated in the challenge to reimagine the traditional silver service. Alessi had already played an influential role in the history of modern design, producing a number of iconic coffeepots. Patrizia Scarzella, *Steel & Style: The Story of Alessi Household Ware* (Milan, 1987), 100–107, 149–72.

Checklist

LUDOLF BACKHUYSEN
Dutch, 1630–1708
*Coastal Scene with a Man-of-War and Other
Vessels,* 1692
Oil on canvas; 33 ⅞ × 43 ⅞ in.
(86.0 × 111.4 cm)
Detroit Institute of Arts, Museum Purchase,
Robert H. Tannahill Fund, General Museum
Funds, New Endowment Fund, Mr. and
Mrs. Benson Ford Fund, Henry Ford II
Fund, Mr. and Mrs. Walter B. Ford II Fund,
Josephine and Ernest Kanzler Foundation
Fund, J. Lawrence Buell Fund, K.T. Keller
Fund, Macauley Fund, Laura H. Murphy
Fund, Barbara L. Scripps Fund, Mr. and
Mrs. Allan Shelden III Fund, Henry E. and
Consuelo Wenger Fund, Matilda R. Wilson
Fund, Mr. and Mrs. Horace E. Dodge
Memorial Fund; gifts of James E. Scripps,
John L. Booth and Mrs. Virginia Booth
Vogel, Mr. and Mrs. Edgar B. Whitcomb,
Dr. Wilhelm R. Valentiner, Edsel B. Ford
Fund, Earhart Foundation, Mr. and Mrs. Lee
Hills, Estate of Bela Hubbard, Kleinberger
Galleries, Anthony F. Reyre, Mrs. Joseph B.
Schlotman, E. and A. Silberman, Mr. and
Mrs. Edgar B. Whitcomb and Mr. and Mrs.
Lawrence P. Fisher, by exchange, 2002.134
[cat. 10]

JEAN BEAUCAIRE
French (Toulouse), active 1714/15; died
1753/54
Coffeepot, ca. 1724–25
Silver and wood; 10 × 10 ¾ × 5 ⅝ in.
(25.4 × 27.3 × 14.3 cm)
Detroit Institute of Arts, Founders Society
Purchase, the Joseph H. Boyer Memorial
Fund, 56.16
[cat. 25]

Probably by MARTIN BERTHE
French (Paris), master 1712
Tea Service with Fitted Case, 1728–29
Silver and ebonized wood, porcelain, glass,
kingwood, rosewood; Teapot: 4 ¼ × 6 ¾ × 4
in. (10.8 × 17.1 × 10.2 cm); Tea Canister:
3 ⅞ × 2 ⁵⁄₁₆ × 1 ¹⁵⁄₁₆ in. (9.8 × 5.9 × 4.9 cm);
Sugar Bowl: 4 ⅛ × 3 ¾ in. (10.5 × 9.5 cm);
Tea Bowl: 2 × 3 ¼ in. (5.1 × 8.3 cm); Saucer:
1 ⅛ × 5 ⁵⁄₁₆ in. (2.9 × 13.5 cm); Scent Flask:
5 ⅜ × 1 ⅞ × ¾ in. (13.7 × 4.8 × 1.9 cm);
Spoons, each: 4 ⅝ × 1 in. (11.7 × 2.5 cm);
Box: 6 × 10 ¼ × 8 ¾ in. (15.2 × 26 × 22.2 cm)
Museum of Fine Arts Boston, Elizabeth
Parke Firestone and Harvey S. Firestone, Jr.
Collection, 1993.520.1-8
[cat. 68]

Designed by ROBERT BONNART, French,
1658–after 1729; engraved by NICOLAS
BONNART, French, 1637–1718
Un cavalier, et une dame beuvant du chocolat,
1690–1710
Hand-colored engraving, faced on reverse
with fabrics; 10 $^{11}/_{16}$ × 7 $^{11}/_{16}$ in. (27.1 × 17.8 cm)
The Morgan Library and Museum,
New York, 2002.19
[cat. 8]

BUEN RETIRO MANUFACTORY
Spain (1759–1808)
Traveling Box with Cup and Saucer, ca. 1800
Leather, wood, metal; porcelain with gilding;
glass; Cup: 4 $^{5}/_{8}$ × 3 $^{1}/_{16}$ × 3 $^{15}/_{16}$ in. (11.8 × 7.8 ×
10 cm); Saucer: 1 $^{1}/_{4}$ × 5 $^{1}/_{4}$ in. (3.2 × 13.4 cm);
Box (closed): 6 $^{3}/_{16}$ × 7 $^{7}/_{8}$ × 6 in. (15.7 × 20 ×
15.2 cm)
Cooper Hewitt, Smithsonian Design
Museum, Smithsonian Institution, Gift of
Eleanor and Sarah Hewitt, 1931-41-7-a/c
[cat. 9]

CHELSEA PORCELAIN MANUFACTORY
England (ca. 1745–84)
Goat and Bee Jug, 1745/49
Soft-paste porcelain; 4 $^{3}/_{8}$ × 3 $^{1}/_{4}$ × 2 in.
(11.1 × 8.3 × 5.1 cm)
Detroit Institute of Arts, Founders Society
Purchase, Visiting Committee for European
Sculpture and Decorative Arts in honor of
Elizabeth DuMouchelle, 2000.93
[cat. 65]

CHINA
Cup Stand, 1127–1279
Wood and lacquer; 3 $^{1}/_{2}$ × 3 $^{7}/_{8}$ in.
(8.9 × 9.8 cm)
Detroit Institute of Arts, Founders Society
Purchase, Acquisitions Fund, 79.150
[cat. 53]

Tea Bowl, 960/1279
Stoneware with iron "hare's fur" glaze;
1 $^{3}/_{4}$ × 4 $^{1}/_{4}$ in. (4.4 × 10.8 cm)
Detroit Institute of Arts, Gift of Mrs. James
Marshall Plumer, 62.18
[cat. 52]

CHINA (DEHUA)
Wine Cup, 1662–1722
Porcelain; 1 $^{5}/_{8}$ × 2 $^{1}/_{2}$ × 2 $^{1}/_{4}$ in.
(4.1 × 6.4 × 5.7 cm)
Detroit Institute of Arts, Gift of Donald and
Marilyn Ross in honor of Tracey Albainy,
2000.79
[cat. 57]

PAUL CRESPIN
English (London), 1694–1770
Chocolate Pot with Swizzle Stick, 1738
Silver and wood; Pot: 9 $^{13}/_{16}$ × 10 $^{15}/_{16}$ in.
(25 × 27.5 cm); Stick: 12 $^{11}/_{16}$ × 1 $^{15}/_{16}$ in.
(32.3 × 5 cm)
The Ashmolean Museum, Oxford,
WA1946.111
[cat. 31; not in exhibition]

AELBERT CUYP
Dutch, 1620–91
Landscape with Maid Milking a Cow, ca. 1655
Oil on canvas; 40 × 53 in. (101.6 × 134.6 cm)
Detroit Institute of Arts, Gift of James E.
Scripps, 89.33
[cat. 63]

GIOVANNI DAVID
Italian, 1743–90
*A Man Wearing a Mask Drinking a Cup of
Coffee (Le Masque au Caffé),* Title page to
Divers Portraits, 1775
Etching and aquatint printed in brown on
laid paper; 15 $^{1}/_{2}$ × 10 $^{3}/_{4}$ in. (39.3 × 27.2 cm)

Detroit Institute of Arts, Founders Society
Purchase, Benson and Edith Ford Fund,
73.172.1
[cat. 13]

JEAN DUCROLLAY
French (Paris), 1708–76
Coffee Grinder (Moulin à café), 1756–57
Yellow, green, and rose gold, steel, and ivory;
3¾ × 2 1/16 in. (9.5 × 5.2 cm)
Paris, Musée du Louvre, Département des
Objets d'art, OA 11950
[cat. 15]

PHILIPPE SYLVESTRE DUFOUR
French, 1622–87
*Traitez nouveaux & curieux du café, du thé et
du chocolate. Ouvrage également nécessaire aux
Medecins & à tous ceux qui aiment leur santé,*
1688 (2nd ed.)
Engraved frontispiece; 5½ in. (14 cm)
Special Collections Library, University of
Michigan Library
[cat. 2]

DU PAQUIER PORCELAIN
MANUFACTORY
Austria (active 1719–1864)
Lady at Her Breakfast, 1737–44
Based on an engraving of 1734 by Laurent
Cars, French, 1699–1771; after a composition
by François Boucher, French, 1703–70
Hard-paste porcelain with polychrome
enamel decoration and gilding; 6¼ × 8 ×
5⅜ in. (15.9 × 20.3 × 13.7 cm)
The Metropolitan Museum of Art, New York,
Gift of Irwin Untermyer, 1964 [64.101.274]
[cat. 61]

ENGLAND
*Twelve Teaspoons, One Strainer Spoon, and a
Pair of Sugar Nippers,* ca. 1750
Silver; Teaspoons, each: 4 11/16 × ⅞ in.
(11.9 × 2.2 cm); Strainer Spoon: 5 7/16 × 13/16 in.
(13.8 × 2 cm); Sugar Nippers: 5¼ × 1 15/16 in.
(13.3 × 4.9 cm)
Sterling and Francine Clark Art Institute,
Williamstown, Massachusetts, USA,
1955.141.1–14
[cat. 30]

ENGLAND (LONDON)
Sugar Box, 1678
Silver; 4¾ × 7 × 9 in.
(12.1 × 17.8 × 22.9 cm)
Private Midwest collection
[cat. 64]

ENGLAND (STAFFORDSHIRE)
Pineapple Coffeepot, ca. 1750
Creamware with colored glazes;
9¾ × 4⅝ × 8⅛ in. (24.8 × 11.8 × 20.7 cm)
Detroit Institute of Arts, 61.90
[cat. 26]

Teapot, eighteenth century
Red stoneware; 4⅜ × 6⅞ × 4 in.
(11.1 × 17.5 × 10.16 cm)
Detroit Institute of Arts, Gift of Captain
Samuel M. Eppley, 61.11
[cat. 48]

Teapot, 1750
Salt-glazed stoneware with polychrome
enamel decoration; 4 × 6¾ × 3¾ in.
(10.2 × 17.1 × 9.5 cm)
Detroit Institute of Arts, Bequest of
Robert H. Tannahill, 70.533
[cat. 49]

Possibly made by Whieldon Factory
Teapot, ca. 1750
Lead-glazed agate ware; 4¾ × 6⅞ × 4 in.
(12.07 × 17.5 × 10.2 cm)
Detroit Institute of Arts, Bequest of Jerome I.
Smith, F81.133
[cat. 51]

ETHIOPIA
Coffeepot (Jebena), twentieth century
Earthenware; 21⅜ × 10½ in.
(54.3 × 26.7 cm)
Michigan State University Museum,
East Lansing, MI
[cat. 12]

THOMAS FARREN
English (London), active 1707; died 1743
Pair of Waiters, 1726/27
Silver; each: ¾ × 5¼ × 5¼ in.
(1.9 × 13.3 × 13.3 cm)
Detroit Institute of Arts, Anonymous bequest,
62.91
[cat. 38]

PIERRE FILLOEUL
French, born 1696
After Jean-Siméon Chardin, French,
1699–1779
Dame prenant son thé, mid-eighteenth century
Etching printed in black ink on laid paper;
image: 10½ × 12⅝ in. (26.6 × 32 cm)
Detroit Institute of Arts, Founders Society
Purchase, Hal H. Smith Fund, 57.90
[cat. 23]

DENIS-FRANÇOIS FRANCKSON
French, master 1765
Coffeepot, 1789
Silver, wood; 3⅞ × 8 × 3 in.
(9.8 × 20.3 × 7.6 cm)
Detroit Institute of Arts, Founders Society

Purchase with funds from Esther Cutler in
memory of Robert H. Tannahill, 72.297
[cat. 27]

FÜRSTENBERG PORCELAIN FACTORY
Germany (1747–present)
Tea and Coffee Service, ca. 1760
Hard-paste porcelain with polychrome
enamel decoration and gilding; Coffeepot:
8⅛ × 6½ × 4⅜ in. (20.6 × 16.5 × 11.1 cm);
Milk Jug: 5⅝ × 3 × 4¼ in. (14.3 × 7.6 ×
10.8 cm); Teapot (large): 3¾ × 6½ × 3⅝
in. (9.5 × 16.5 × 9.2 cm); Teapot (small): 3
× 5¼ × 3¼ in. (7.6 × 13.3 × 8.3 cm); Coffee
Cups, each: 1¾ × 3⅞ × 3¹³⁄₁₆ in. (4.4 × 9.8 ×
8.1 cm); Saucers for Coffee Cups, each: 1 ×
5⁹⁄₁₆ in. (2.5 × 14 cm); Tea Cups, each: 1½ ×
3½ × 2⅞ in. (3.8 × 8.9 × 7.3 cm); Saucers for
Tea Cups, each: ⅞ × 4¾ in. (2.2 × 12.1 cm)
Detroit Institute of Arts, Anonymous bequest,
62.86.1A–14B
[cat. 44]

GERMANY (RAEREN)
Jug, 1590/1600
Salt-glazed earthenware and pewter;
11¼ × 7¾ × 7⅜ in. (28.58 × 19.7 × 18.7 cm)
Detroit Institute of Arts, Gift of Victor Spark
and John Mitchell, 45.140
[cat. 17]

GERMANY (SIEGBURG)
Jug (Pulle) with Medallion of Helen of Troy,
ca. 1586
Salt-glazed stoneware and pewter;
7¼ × 7 × 7 in. (18.4 × 17.8 × 17.8 cm)
Detroit Institute of Arts, Gift of the Stroh
Brewery Company in Memory of Peter W.
Stroh, 2002.60
[cat. 19]

GERMANY OR ENGLAND
Bear Stein, ca. 1750
Earthenware and pewter; 9 × 6½ × 4¾ in.
(22.9 × 16.5 × 12.1 cm)
Detroit Institute of Arts, Gift of the Stroh
Brewery Company in Memory of Peter W.
Stroh, 2002.58
[cat. 18]

THOMAS GRAHAM and JACOB WILLIS
British, active 1789–91
Tea Caddy, 1789
Silver and ivory; 6 × 6 × 3¾ in.
(15.2 × 15.2 × 9.5 cm)
Private Midwest collection
[cat. 29]

THOMAS HEMING
English (London), ca. 1722–1801
Tea Urn, 1777–78
Silver; 17¹³⁄₁₆ × 7⁵⁄₁₆ × 6⅞ in.
(45.2 × 18.5 × 17.5 cm)
Cooper Hewitt, Smithsonian Design
Museum, Smithsonian Institution, Gift of the
Estate of James Hazen Hyde, 1960-1-23-a/d
[cat. 36]

JOHANN ERHARD HEUGLIN II and
other artists
German, active 1717–57
Meissen Porcelain Manufactory
Breakfast Set, ca. 1728–29
Gilt silver, hard-paste porcelain, glass, and
leather; Case: 10⁹⁄₁₆ × 19⅜ × 14½ in.
(26.8 × 49.2 × 36.8 cm)
Sterling and Francine Clark Art Institute,
Williamstown, MA, 2012.4.1–13
[cat. 20]

HÖCHST CERAMICS MANUFACTORY
Germany (1746–96)
Audience of the Chinese Emperor, 1766
Modeled by Johann Peter Melchior, German,
1742–1825
Hard-paste porcelain with polychrome
enamel decoration and gilding; 16⅛ × 13 ×
9 in. (41 × 33 × 22.9 cm)
Detroit Institute of Arts, Gift of James S.
Holden in memory of his mother, Mrs. E. G.
Holden, 51.59
[cat. 59]

ITALY (VENICE)
Calcedonio Cup and Saucer (Trembleuse),
early 18th century
Agate glass (calcedonio); Cup: 3½ × 3 in.
(8.9 × 7.6 cm); Saucer: 1¾ × 4⅞ in. (4.4 ×
12.4 cm)
Toledo Museum of Art, Ohio, Purchased
with funds from the Libbey Endowment,
Gift of Edward Drummond Libbey,
2005.51A–B
[cat. 35]

JAPAN
Vessel for Hot Water, late 15th–early 16th
century
Wood, red and black lacquer (Negoro ware);
12⅝ × 11½ × 8 in. (32.1 × 29.2 × 20.3 cm)
Detroit Institute of Arts, Founders Society
Purchase, Acquisitions Fund, 1983.1
[cat. 11]

DAVID LE MARCHAND
French, active in Britain, 1674–1726
Bust of a Gentleman, possibly Joseph Addison,
ca. 1707
Ivory; 10½ × 6 × 3 in. (26.7 × 15.2 × 7.6 cm)
Detroit Institute of Arts, Museum
Purchase, Joseph M. de Grimme Memorial
Endowment Fund, funds from Stanford

Stoddard, Gilbert B. and Lila Silverman,
and the Visiting Committee for European
Sculpture and Decorative Arts in honor of
Alan Darr; gifts from Mrs. Horace E. Dodge,
by exchange, 2003.1
[cat. 22]

JEAN-BAPTISTE LE PRINCE
French, 1734–81
Fear (La Crainte), 1769
Oil on canvas; 19 ¾ × 25 ¼ in. (50 × 64 cm)
Toledo Museum of Art, Ohio, Purchase with
funds from the Libbey Endowment, Gift of
Edward Drummond Libbey, 1970.444
[cat. 7]

MAYAN CULTURE
El Petén, Guatemala
Codex Style Cylinder Vase, 600–900
Earthenware with painted slip decoration;
4 ¾ × 4 ¼ in. (12.1 × 10.8 cm)
Inscription: "Here is it being written the
drinking vessel for the fruit of the cacao tree
of Sak."
Detroit Institute of Arts, Gift of Joyce and
Avern Cohn, 1990.289
[cat. 5]

Tripod Vessel with Slab Legs, 300–600
Earthenware with stucco and polychrome
pigments; 10 ½ × 8 in. (26.7 × 20.3 cm)
Detroit Institute of Arts, Founders Society
Purchase, Arthur H. Nixon Fund, 1984.12
[cat. 4]

MEISSEN PORCELAIN MANUFACTORY
Germany (active 1710–present)
Coffeepot, 1710–15
Modeled by Johann Friedrich Böttger,
German, 1682–1719
Stoneware and silver-gilt mounts;
7 × 3 ¾ × 5 ⅜ in. (17.8 × 9.5 × 13.7 cm)

Detroit Institute of Arts, Founders Society
Purchase, Ruth Nugent Head Bequest Fund,
1986.18
[cat. 41]

Pair of Quatrefoil Cups and Saucers, ca. 1735
Hard-paste porcelain with polychrome
enamel decoration and gilding; Cups, each:
1 ⅞ × 3 ¾ × 3 in. (4.8 × 9.5 × 7.6 cm);
Saucers, each: 1 ¼ × 4 ⅞ × 4 ¼ in.
(3.2 × 12.4 × 10.8 cm)
Detroit Institute of Arts, Anonymous bequest,
62.75.1A–2B
[cat. 43]

Sultan Riding an Elephant, ca. 1749
Modeled by Johann Joachim Kändler,
German, 1706–75, and Peter Reinicke,
German, 1715–68
Hard-paste porcelain with polychrome
enameling; gilt bronze; 15 ⅜ × 14 ½ × 8 ⅞ in.
(39 × 37 × 22.5 cm)
Detroit Institute of Arts, Museum Purchase,
Robert H. Tannahill Foundation Fund,
Gilbert B. and Lila Silverman, and the
Visiting Committee for European Sculpture
and Decorative Arts, 2004.11
[cat. 16]

Teapot, 1723 / 24
Decorated by Johann Gregor Höroldt,
German, 1696–1775
Hard-paste porcelain with polychrome
enamel decoration, gilding, and silver gilt
mounts; 5 × 4 ¼ × 6 ½ in. (12.7 × 10.8 ×
16.5 cm)
Detroit Institute of Arts, Founders Society
Purchase, Gift of Ruth Nugent Head and
City of Detroit, by exchange, 1992.43
[cat. 50]

Turkish Coffee Cup, 1774/1814
Hard-paste porcelain with polychrome
enamel decoration and gilding; 1 ⅜ × 2 ⁵⁄₁₆ in.
(3.5 × 5.9 cm)
Detroit Institute of Arts, Gift of Mr. and Mrs.
Marc Patten, 55.54.A
[cat. 56]

CHARLES PHILIPS
English, 1708−47
The Strong Family, 1732
Oil on canvas; 29 ⅝ × 37 in. (75.2 × 94 cm)
The Metropolitan Museum of Art, New
York, Gift of Robert Lehman, 1944 (44.159)
[cat. 21]

PEZÉ PILLEAU
English (London), 1696−1776
Footed Salver, 1740
Silver; 1 ¼ × 10 × 9 in. (3.2 × 25.4 × 22.9 cm)
Private Midwest collection
[cat. 39]

FRANS POST
Dutch, 1612−80
View of the Jesuit Church at Olinda, Brazil,
1665
Oil on canvas; 22 ⅛ × 32 ⅞ in.
(56.2 × 83.5 cm)
Detroit Institute of Arts, Founders Society
Purchase, General Membership Fund, 34.188
[cat. 62]

ROYAL FACTORY OF ALCORA
Spain (active 1727−ca. 1858)
Jícara (chocolate cup), 1740−60
Tin-glazed earthenware; 2 ⅞ × 2 ¹³⁄₁₆ in.
(7.3 × 7.2 cm)
The Hispanic Society of America, New York,
E872
[cat. 33]

Mancerina (saucer for chocolate cup), 1740−60
Tin-glazed earthenware; 2 ¹⁄₁₆ × 7 ⁵⁄₁₆ × 7 ¹⁄₁₆ in.
(5.2 × 18.6 × 17.9 cm)
The Hispanic Society of America, New York,
LE1921
[cat. 34]

ROYAL WORCESTER
England (established 1751)
Sugar Bowl, ca. 1770
Soft-paste porcelain with polychrome enamel
decoration and gilding; 5 ¾ × 4 ⅝ in. (14.6 ×
11.7 cm)
Detroit Institute of Arts, Gift of Robert H.
Tannahill, 51.18
[cat. 66]

"Two Quail" Tea Service, 1765−70
Soft-paste porcelain with polychrome enamel
decoration and gilding; Teapot: 6 ⅛ × 8 ×
4 ½ in. (15.6 × 20.3 × 11.4 cm); Tea Caddy:
7 ¼ × 3 ½ in. (18.4 × 8.9 cm); Sugar Bowl:
5 ½ × 4 ⅛ in. (14 × 10.5 cm); Cream Pitcher:
4 ¼ × 4 × 3 ¼ in. (10.8 × 10.2 × 8.3 cm);
Tea Bowl: 3 × 6 ½ in. (7.6 × 16.5 cm); Spoon
Tray: ¾ × 3 ½ × 6 in. (1.9 × 8.9 × 15.2 cm);
Teacup: 2 × 3 ¼ in. (5.1 × 8.3 cm); Saucer:
1 ¼ × 5 ½ in. (3.2 × 1.4 cm)
From the Collections of The Henry Ford,
Dearborn, Michigan, Gift of Mrs. Ernest R.
Breech in memory of her late husband,
79.45.2
[cat. 45]

SAINT-CLOUD PORCELAIN
MANUFACTORY
France (active by 1693−1766)
Cup and Saucer, ca. 1720
Soft-paste porcelain; Cup: 2 ⅝ × 3 ⁵⁄₁₆ × 2 ¹¹⁄₁₆
in. (6.7 × 9 × 6.8 cm); Saucer: 1 × 4 ⁹⁄₁₆ in.
(2.5 × 11.6 cm)
Detroit Institute of Arts, Gift of

Mr. and Mrs. Norman D. Jordan, 53.325
[cat. 54]

BARTHELEMY SAMSON
French (Toulouse), active 1760; died 1782
Hot Milk Pot, ca. 1764
Silver and ebonized wood; 5 ½ × 5 ⅛ × 3 ⅞ in.
(14 × 13 × 9.8 cm)
Detroit Institute of Arts, Bequest of
Robert H. Tannahill, 70.399
[cat. 40]

SÈVRES PORCELAIN MANUFACTORY
France (1740–present)
Cup and Saucer, ca. 1785
Soft-paste porcelain with polychrome
enamel decoration and gilding;
Cup: 3 ⅛ × 3 ⅞ × 2 ⅞ in. (7.9 × 9.8 × 7.3 cm);
Saucer: 1 ⅜ × 6 × 6 in. (3.5 × 15.2 × 15.2 cm)
Detroit Institute of Arts, Bequest of Bernard
Savage Reilly, 1999.87
[cat. 42]

Pair of Triangular Potpourri Vases, 1761
Designed by Jean-Claude Duplessis, père,
Italian, 1690–1774; decorated by Charles-
Nicolas Dodin, French, 1734–1803
Soft-paste porcelain with polychrome enamel
decoration and gilding; Each: 11 ½ × 6 ½ ×
7 in. (29.2 × 16.5 × 17.8 cm)
Detroit Institute of Arts, Bequest of
Mrs. Horace E. Dodge in memory of her
husband, 71.246–247
[cat. 60]

Tea and Coffee Service, 1842–43
Designed by Hyacinthe Régnier, French,
1803–70; painted by Pierre Huard, French,
active 1811–46/47
Hard-paste porcelain with polychrome
enamel decoration and gilding; Octafoil Tray:
8 ½ × 20 in. (21.6 × 50.8 cm); Waste Bowl:

3 ¾ × 9 in. (9.5 × 22.9 cm); Coffeepot: 7 ½ ×
5 ¾ in. (19.1 × 14.6 cm); Double-Handled
Sugar Bowl: 4 ⅜ × 5 ⅝ in. (11.1 × 14.3 cm);
Teapot: 5 ⅜ × 7 ⅝ in. (13.7 × 19.4 cm); Milk
Jug: 5 × 4 ⅜ in. (12.7 × 11.1 cm); Cups,
each: 1 ¹¹⁄₁₆ × 2 ⅞ in. (4.3 × 7.3 cm); Saucers,
each: ¼ × 4 ¹⁵⁄₁₆ in. (0.6 × 12.5 cm)
Detroit Institute of Arts, Museum Purchase
in memory of Tracey Albainy with a gift
from Gordon L. and Linda A. Stewart,
and the Joseph M. de Grimme Memorial
Fund, Joseph H. Parsons Fund, Ralph H.
Booth Bequest Fund, Edgar A. V. Jacobsen
Acquisition Fund; gift of K. T. Keller, by
exchange, and donations from Gilbert B.
and Lila Silverman, John Stroh and Vivian
Day, Bonnie and Bob Larson, Anthony L.
Soave, Peter and Tina Barnet, Dr. and Mrs.
Gerhardt A. Hein, Hervé Aaron, Graham W.J.
Beal, Maggie Boleyn, Antonia Boström,
Dr. Alan P. Darr and Mrs. Mollie Fletcher,
Dr. Theodore and Mrs. Diana Golden, Dr.
and Mrs. Reginald Harnett, Armin Allen,
Henry S. and Charissa B. David, Gina
and Herbert Granger, Jennifer Moldwin
Gustafson, Barbara Heller, Mr. and Mrs.
Joseph L. Hudson, Jr., Mary Hughes, Julian
and Ruth Lefkowitz, Iva Lisikewycz, George
and Elaine Keyes, Paul F. Palace, Jr. and
Pam Watson-Palace, Michele Rambour,
Charlotte Robson, Donald Ross, Nancy
Sojka, Victor Tahill, Curl Tutag, MaryAnn
Wilkinson, Gillian Wilson, Maria Santangelo
Brown, Andrew L. Camden and Gayle Shaw
Camden, Claudia Crable, Christina and
Antoine d'Albis, Aileen Dawson, Dr. Heather
Ecker, Jacquelin Eckhous, John and Bonita
Fike, Carol Forsythe, Paul Micio, Mary Lee
Obryan, Jim and Adrienne Rudolph, Mr. and
Mrs. Ted Wasson, Brian Gallagher and Terry
Prince, Rose Ann Comstock, Kimberly K.
Dziurman, Shirley Mopper, Mr. and Mrs.

Leonard Rynski, Michele Ryce-Elliott, Michelle Smith, Irma Stevens, Ms. Audrey Zupmore, 2008.15.1–14
[cat. 58]

SPAIN
A True Report of the Great Sermon that Mahomet Calipapau, of Russian Nationality, the Great Prior of Escanzaona, and the Archbishop of Lepanto, Doctor Degreed in the Texts and Paragraphs of the Koran preached in the Parroquial Mosque of Babylon, 1684
Ink on parchment; Open: 8¼ × 12¼ in. (21 × 31.1 cm)
The Hispanic Society of America, New York, HC 313/521
[cat. 3]

JAN STEEN
Dutch, 1626–79
Gamblers Quarreling, ca. 1665
Oil on canvas; 27¾ × 35 in. (70.5 × 88.9 cm)
Detroit Institute of Arts, Gift of James E. Scripps, 89.46
[cat. 1]

TURKEY
Coffee Service, nineteenth century
Silver, turquoise, and coral
Tray: 11¾ in. (29.8 cm); Coffeepot: 7⅝ in. (19.4 cm); Cup Holders, each: 2 in. (5.1 cm)
The Metropolitan Museum of Art, Gift of Valerie J. Dreyfus, 1949 [49.147.1–8]
[cat. 67]

PIERRE VALLIÈRES
French (Paris), master 1776
Chocolate Pot, 1781
Silver; 10¼ × 9⅜ × 5¼ in. (26 × 23.8 × 13.3 cm)
The Metropolitan Museum of Art, New York, Rogers Fund, 1928 [28.156]
[cat. 32]

CARLE VAN LOO
French, 1705–65
La sultane (Madame de Pompadour as a Sultana), 1755
Oil on canvas; 51³⁄₁₆ × 63 in. (130 × 160 cm)
Paris, Les Arts Décoratifs, Department XVII C./XVIII C., inv. no. 26544
[cat. 14]

Workshop of DIEGO RODRÍGUEZ DE SILVA Y VELÁZQUEZ
Spanish, 1599–1660
Infanta Maria Theresa, 1653
Oil on canvas; 50⅝ × 39⅝ in. (128.6 × 100.6 cm)
Museum of Fine Arts, Boston, Gift of Charlotte Nichols Greene in memory of her father and mother, Mr. and Mrs. Howard Nichols, 21.2593
[cat. 6]

VIENNA PORCELAIN MANUFACTORY
Austria (1744–1864)
Tea and Coffee Service, ca. 1804
Hard-paste porcelain with polychrome enamel decoration and gilding; Tray: 1¼ × 16¼ × 13¹⁄₁₆ in. (3.2 × 41.3 × 33.2 cm); Coffeepot: 5⅜ × 4½ × 3⅛ in. diam. (13.7 × 11.5 × 8.0 cm); Teapot: 4⅞ × 5⅞ × 3⅜ in. (12.5 × 15.0 × 8.5 cm); Milk Jug: 4⅞ × 4⅛ × 3 in. diam. (12.4 × 10.6 × 7.5 cm); Sugar Bowl: 3⅛ × 3⅝ in. (8.0 × 9.3 cm); Cups, each: 2½ × 2½ in. (6.2 × 6.2 cm); Saucers, each: 1⅛ × 5⅜ in. (2.7 × 13.6 cm)
Detroit Institute of Arts, Founders Society Purchase with funds from the Visiting Committee for European Sculpture and Decorative Arts, 1988.69.1–7
[cat. 46]

Attributed to HENDRIK VOET
Dutch (Zwolle), 1654–1737
Tea Caddy, ca. 1700
Tortoiseshell, with silver inlay, silver mounts;
wooden core and inset base; 4 3/16 × 2 15/16 ×
1 7/8 in. (10.7 × 7.4 × 4.7 cm)
Museum of Fine Arts, Boston, Elizabeth
Parke Firestone and Harvey S. Firestone, Jr.
Collection, 1993.452
[cat. 28]

WEDGWOOD
England (1759–present)
Cup and Saucer, ca. 1790
Caneware; Cup: 2 9/16 × 3 × 3 3/4 in.
(6.5 × 7.6 × 9.5 cm); Saucer: 1 1/4 × 5 1/16 in.
(3.2 × 12.9 cm)
Detroit Institute of Arts, Gift of
Mr. and Mrs. Norman D. Jordan, 53.446
[cat. 55]

ADAM WEISWEILER
French, 1750–1810
*Combination Writing, Working, and Dining
Table,* ca. 1785
Mahogany, white marble, and gilt bronze;
H. 29 3/4 × 26 1/8 in. (75.6 × 66.36 cm)
Detroit Institute of Arts, Bequest of
Mrs. Horace E. Dodge in memory of her
husband, 71.172
[cat. 47]

THOMAS WHIPHAM THE ELDER
English (London), 1715–85
Kettle and Stand, 1740–48
Silver and wood; Kettle: 10 5/8 × 10 7/8 × 7 1/2 in.
(27 × 27.6 × 19.1 cm) Stand: 5 1/8 × 7 3/4 × 7 3/8
in. (13 × 19.7 × 18.7 cm)
Private Midwest collection
[cat. 37]

JOHN WHITE
English, active 1719; died 1789(?)
Coffeepot, ca. 1724
Silver and wood; 10 × 7 1/16 × 6 1/4 in.
(25.4 × 18 × 15.9 cm)
Detroit Institute of Arts, Founders Society
Purchase, William H. Murphy Fund, 43.37
[cat. 24]

Selected Bibliography

Albrecht, Peter. "Coffee-Drinking as a Symbol of Social Change in Continental Europe in the Seventeenth and Eighteenth Centuries." *Studies in Eighteenth-Century Culture* 18 (1988): 91–103.

Barnes, Laurie. *High Tea: Glorious Manifestations East and West*. Exh. cat., Norton Museum of Art. West Palm Beach, FL, 2015.

Burnett, John. *Liquid Pleasures: A Social History of Drinks in Modern Britain*. London and New York, 1999.

Chen, Ching-Jung. "Tea Parties in Early Georgian Conversation Pieces." *The British Art Journal* 10 (2009): 30–39.

Cowan, Brian. *The Social Life of Coffee: The Emergence of the British Coffeehouse*. London and New Haven, 2005.

Dulau, Anne. *Boucher and Chardin: Masters of Modern Manners*. Exh. cat., The Wallace Collection, London. London and Glasgow, 2008.

Ellis, Markham, Richard Coulton, and Matthew Mauger. *Empire of Tea: The Asian Leaf that Conquered the World*. London, 2015.

Goodman, Jordan, Paul E. Lovejoy, and Andrew Sherratt Goodman, eds. *Consuming Habits: Drugs in History and Anthropology*. London and New York, 1995.

Grivetti, Louis E., and Howard Yana-Shapiro, eds. *Chocolate: History, Culture, and Heritage*. Hoboken, NJ, 2009.

Hellman, Mimi. "Of Water and Chocolate." *Gastronomica: The Journal of Critical Food Studies* 4 (2004): 9–11.

Hohenegger, Beatrice, ed. *Steeped in History: The Art of Tea*. Exh. cat., Fowler Museum at UCLA. Los Angeles, 2009.

Jamieson, Ross W. "The Essence of Commodification: Caffeine Dependencies in the Early Modern World." *Journal of Social History* 35 (2001): 269–94.

Jones, Christine. "Exotic Edible: Coffee, Tea, Chocolate, and the Early Modern French How-to." *Journal of Medieval and Early Modern Studies* 43, no. 3 (2013): 623–53.

Landweber, Susan. "'This Marvelous Bean': Adopting Coffee into Old Regime French Culture and Diet." *French Historical Studies* (2015): 193–203.

Liberles, Robert. *Jews Welcome Coffee: Tradition and Innovation in Early Modern Germany.* Waltham, MA, 2012.

McCabe, Ina Baghdiantz. *Orientalism in Early Modern France: Eurasian Trade, Exoticism, and the Ancien Régime.* Oxford and New York, 2008.

Mintz, Sidney. *Sweetness and Power: The Place of Sugar in Modern History.* New York, 1985.

North, Michael. *Material Delight and the Joy of Living: Cultural Consumption in the Age of Enlightenment in Germany.* Translated by Pamela Selwyn. Aldershot and Burlington, VT, 2008.

Norton, Marcy. *Sacred Gifts, Profane Pleasures: A History of Tobacco and Chocolate in the Atlantic World.* Ithaca and London, 2008.

Smith, Woodruff. *Consumption and the Making of Respectability, 1600–1800.* London, 2002.

Wees, Beth Carver. *English, Irish, and Scottish Silver at the Sterling and Francine Clark Institute.* New York, 1997.

Weinberg, Bennett K., and Bonnie K. Bealer. *The World of Caffeine: The Science and Culture of the World's Most Popular Drug.* London and New York, 2001.

ACKNOWLEDGMENTS

Many colleagues and museum professionals have provided valuable assistance during the preparation of this catalogue and the exhibition. I am especially grateful to the following for patiently answering queries, responding to frantic calls for information, and offering leads for research: Pablo Alvarez, Katharine Baetjer, Laurie Barnes, Michele Bimbenet-Privat, Aisha Burtenshaw, Keith Christiansen, Sarah Coffin, Annick Des Roches, Anne Forray-Carlier, Nikolai Grube, Jack Hinton, Brian Kennedy, Ned Lazaro, Christian Lechelt, Patrick Lenaghan, Margaret Connors McQuade, Thomas Michie, Macarena Moralejo, Kathleen Morris, Jeffrey Munger, John O'Reilly, Lawrence Nichols, Jutta Page, Charles Sable, Elizabeth Spencer, Denny Stone, Lynne Swanson, Jennifer Tonkovich, Jeffrey Weaver, and Timothy Wilson. To my co-authors Mimi Hellman and Hope Saska, I offer my appreciation for their thoughtful and lively essays, as well as my warmest thanks for their early and ongoing encouragement. Particular thanks are owed to Lisa Bessette for always being my best reader and Patty Inglis for her splendid eye for design.

Although the project was initiated under former director Graham Beal, current director (and former European Art department head) Salvador Salort-Pons has been unstinting in his support of the project from its earliest stages. Co-chief curators Nancy Barr and Nii Quarcoopome offered much-needed support at critical moments, while my exhibition team members—Swarupa Anila, director of interpretive engagement, and Melanie Parker, Kress interpretive fellow—have pushed me to think deeper and better about the material. I have also benefited from the insights and counsel of both our community advisory and academic advisory panels.

My heartfelt thanks to the many staff members at the Detroit Institute of Arts who have lent generously of their counsel, expertise, and skills: Terry Birkett, director of collections management, and his stalwart team of museum technicians; Christopher Foster and John Cummins Steele in conservation; Paul Andrews and Meghan Connolly in grants; Amy Hamilton Foley and Kimberly Long in exhibitions; Susan Higman Larsen, director of publishing and collections information, and her extraordinary *neko*-loving team; Amy Dunn, Terry Segal, and Michelle Smith in the registrar's office; and Barbara Heller in exhibitions and collection strategies. Special thanks are extended to Maria Ketcham, director of research library and archives, and her interns Danae Dracht and Sara Ausilio, who processed a great number of interlibrary loans on behalf of this project. In addition, curatorial intern Alexandra Nickolaou provided crucial research support and much needed conviviality. Photographers Scott Lane and Eric Wheeler tolerated my tedious requests for details and particular views with great cheer and I am indebted to their technical talent, as well as their deep reserves of patience. Last, but not least, Mellon Fellow in Objects Conservation Aaron Burgess deserves a warm round of applause for ensuring that the silver and porcelain always looked their prettiest before making their way to photography.

YAO-FEN YOU
Associate Curator of European Sculpture and Decorative Arts
Detroit Institute of Arts

Photo Credits

Unless otherwise noted, photographs were provided by the owners.

© 2016 Aerobie, Inc.: Hellman essay, fig. 11; Michael Agee, © Sterling and Francine Clark Art Institute, Williamstown, Massachsetts, USA: cats. 20, 30; Daniel Arnaudet, © RMN–Grand Palaís / Art Resource, NY: cat. 15; Photo Les Arts Décoratifs, Paris / Jean Tholance: cat. 14; Matt Flynn © Smithsonian Institution. Cooper Hewitt, Smithsonian Design Museum / Art Resource, NY: cat. 9; Graham S. Haber, 2016, The Pierpont Morgan Library, New York: cat. 8; © The Metropolitan Museum of Art / Art Resource, NY: cats. 21, 32, 61, 67; Ellen McDermott, © Smithsonian Institution. Cooper Hewitt, Smithsonian Design Museum / Art Resource, NY: cat. 36; © 2016 Museum of Fine Arts, Boston: cats. 6, 28, 68; David Seiler: Hellman essay, fig. 9.

Aerobie and AeroPress are registered trademarks of Aerobie, Inc. Mr. Coffee® is a registered trademark of Sunbeam Products, Inc. Images used with permission.